IMAGES
of America

SALEM

ON THE COVER: Edward and Lillian Lamport and their sons Merrill and Fred sit in their stylish 1910 Pullman automobile. The Pullman car advertised itself as not only the best car at the price but the best car at any price. The model shown in this photograph cost about $3,000. The Pullman automobile went out of production in 1917. The stately building towering over the automobile is the Oregon State Capitol, which was destroyed by fire on April 25, 1935. This photograph was taken shortly before that blaze. (Courtesy of Salem Public Library Historic Photographs Collections, Ben Maxwell Collection.)

IMAGES

of America

SALEM

Tom Fuller, Christy Van Heukelem,
and the Mission Mill Museum

ARCADIA
PUBLISHING

Published by Arcadia Publishing
Charleston, South Carolina

Printed in the United States of America

Library of Congress Control Number: 2008941571

For all general information contact Arcadia Publishing at:
Telephone 843-853-2070
Fax 843-853-0044
E-mail sales@arcadiapublishing.com
For customer service and orders:
Toll-Free 1-888-313-2665

Visit us on the Internet at www.arcadiapublishing.com

To Jason Lee and other founding fathers whose vision and dedication gave birth to an enduring community.

CONTENTS

ACKNOWLEDGMENTS

The authors would like to thank the following individuals and organizations that were key in developing this book: Sandra Allen, Office of the Speaker–Oregon House of Representatives; Martin Morris, Salem and West Valley Hospital Foundations; Bob Repine, Oregon Department of Human Services; Pat Solomon, Oregon Department of Transportation; Roger Plant and Gary Strand, Truitt Brothers, Inc.; Jean Hand, First United Methodist Church; Cynthia Thiessen and Dianna Clark, Salem Public Library; A. C. Gilbert's Discovery Village; Marion County Historical Society; Oregon State Archives; Oregon State Library; and Salem Public Library.

Thanks to Brian Wood at PhotoVision for his belief in the value of legacy and willingness to invest in a photographic book chronicling Salem's past.

Special thanks go to Don Christensen and the many volunteers who have the served this community in researching, creating, and updating the Salem Public Library Historic Photograph Collection.

This book could not have been possible without the photographers and historians of our past. We value and honor the work of Ben Maxwell, Al Jones, George Strozut, Wes Sullivan, and the many others who recorded events of their world.

We would also like to thank our editor, Sarah Higginbotham, who believed in the project and helped us find resources and stay on track to finish.

The photographs in this book are courtesy of the following organizations unless otherwise noted. Photographic abbreviations used in this book are as follows:

ODOT	Oregon Department of Transportation, History Center
OSA	Oregon State Archives
OSL	Oregon State Library
SPL	Salem (Oregon) Public Library Historic Photograph Collections
SPL: SJ	*Statesman Journal*
SPL: M	Ben Maxwell Collection
SPL: J	Al Jones Photographer
SPL: SCC	Salem Chamber of Commerce
SPL: GN	Greg Nelson

INTRODUCTION

The Native Americans called it "Chemeketa." The word means "resting place." Nestled next to the Cascade foothills on the east, a verdant valley and large placid river provided abundant game, fish, fruits, and berries. Chemeketa was the favorite winter camping spot for the Kalapuyas. At its peak, some 14,000 Kalapuyas lived in the Willamette Valley. Around 1812, trappers arrived in the area of Salem, collecting fur and food for companies in Astoria. They built a log shelter and trapping house near the Willamette River, but the exact location isn't known. In 1831, four members of the tribe known as the Flatheads arrived in St. Louis, Missouri, with a desire to learn about the white man's "book of heaven." That meeting spurred the Board of Missions of the Methodist Episcopal Church to organize a mission west, headed by Rev. Jason Lee.

Lee arrived in 1834 and established his mission just north of Salem near the present Wheatland Ferry. After years of struggle, Lee's mission grew, attracting more families from the east and Native Americans from the area. Six years after arriving, Lee moved his mission south a few miles to that favorite camping spot of the Kalapuyas. He called the place by its Native American name, Chemeketa, but most people simply called it "Mill Place" for its proximity to Mill Creek and the Willamette River. Lee built a sawmill and several other buildings, two of which are still on display as the Mission Mill Museum.

Lee helped organize the Oregon Institute, the forerunner to Willamette University, the first university in the West. The mission closed in 1844, but by then a town had been born. One of Jason Lee's missionary colleagues was William Willson. In 1850, Willson filed a plat with the Marion County clerk for a town covering an area 13 blocks by 5 blocks and bounded by the Willamette River and Mission, Church, and Division Streets. He called the town "Salem," from the Hebrew word for peace. In 1855, the city formed its first public school district.

In 1851, Congress voted to move the capital from Oregon City to Salem. A spirited 15-year contest ensued between Salem and Marysville (now Corvallis) for the honor of housing Oregon's state government. In 1855, the territorial government voted to move the capital to Corvallis, only to have it moved back that same year by federal decree. Also in 1855, the first capitol building burned to the ground. Many think it was set on fire as part of the fight with Corvallis. Oregon became the 33rd member of the United States on February 14, 1859, and in 1864 voters reaffirmed the selection of Salem as its capital. Fire consumed Oregon's capitol for a second time in 1935, when it is thought an electrical malfunction in the basement sent flames shooting into the rotunda, which collapsed. Very few items were saved from that blaze, but one is still on display in the Speaker of the House's office. A new capitol took shape that was expanded so much that whole neighborhoods had to be moved.

From its humble beginnings as a Native American winter camp, Salem has grown into the second largest city in Oregon. Fertile farmland surrounds the city, which now crosses the Willamette River to include West Salem in Polk County. Mills, churches, schools, and businesses sprouted up. The Union House, operated by William Cox, sold goods brought over the Oregon Trail and

clothing and hats made from silk and braided wheat straw. Ferries and stern-wheelers plied the waters of the Willamette, carrying goods, mail, and passengers. Sometimes the Willamette swelled to flood stage, inundating communities and farms on both sides of the river. At those times, the stern-wheelers provided a lifeline for those caught by the swiftly rising waters. Occasional snowstorms also snarled traffic and caused buildings to collapse. Through all the natural disasters of flood, wind, and snow, Salem residents pitched in to help evacuate the stranded and clear fallen branches or clogged roads.

The *Oregon Statesman* provided press coverage of the comings and goings beginning in 1851. Telegraph and railroad service soon followed, along with the forerunner of the Oregon State Fair. Salem's cultural and recreational scene began to develop with a large hotel, theater, and restaurants. A thriving business and manufacturing community sprang up near the river's edge, including bakeries, blacksmiths, breweries, sawmills, flour mills, and canneries.

In 1903, Salem took the nickname of "The Cherry City" in honor of its food-processing industry. In addition to agricultural products, logging and wood products also supplied lots of jobs to Salem residents. In 1920, the Oregon Pulp and Paper Company opened near Pringle Creek. The Thomas Kay Woolen Mill became more than just an employer. Salem residents twice put up their own money to fund the mill, and generations worked there. After the mill closed, it became a museum preserving the mill just as it was during production, along with many of Salem's first buildings, like Jason Lee's home. By far the largest employer in Salem is the state government. Numerous state institutions have locations in Salem, including the largest concentration of state prisons plus schools for the blind and deaf and homes for wayward youth.

From a small school aimed at teaching missionary children and area children of settlers, Willamette University grew and thrived, sprouting a medical college and a school for women, a law school, and a school of theology. William Willson donated land to several area church congregations, which encouraged a rich diversity and expression of faith and left beautiful houses of worship that help shape Salem's skyline. The coming of the 20th century saw women win the right to vote. Members of the Woman's Club were instrumental in securing funds from the Carnegie Foundation to build Salem's first library, and Salem's women helped found the Deaconess Hospital, forerunner to today's Salem Memorial Hospital.

Streetcars started transporting the city's rapidly growing population on tracks that crisscrossed the major roads. By the time the last electric streetcar ceased service in 1927 after nearly 40 years, Salem had more than 35 miles of paved roads. Water and sewer systems were constructed, along with Salem's first dial-tone telephone, which arrived in 1931. In 1949, the city annexed the community of West Salem across the Willamette. Interstate 5 crossed Salem at key intersections and encouraged commercial growth away from downtown.

While time deteriorated many areas of the city, Salem has worked diligently to revitalize its downtown. A mall covers many city blocks, bicycle paths and a new park attract picnickers along the river, and new convention and transit centers have transformed an area once dominated by closed factories into a destination area. Salem's roots in agriculture and timber have given way to high technology. A major chip manufacturing company located a plant near Salem's airport, along with other high-tech and metals fabrication companies that have greatly diversified employment opportunities.

Jason Lee could never have imagined that his dream of reaching out to Native Americans would have resulted in a place that retains the beauty of the valley and the river with the vitality of a city still very much the center of Oregon's political and cultural life.

One

BIRTH OF A CITY

The birth of Salem as a community was influenced, as it is to this day, by the Willamette River. According to legend, four Nez Perce (Flathead) Indians walked from the Oregon Territory to St. Louis, Missouri, in hopes of meeting with the Indian agent Gen. William Clark to ask about a "book of heaven" they had heard about. Clark gave them some religious instruction but did not give them a Bible and sent them back home. The Nez Perce also met an unnamed Methodist from the Wyandot tribe. They returned, disappointed, but did not know they had set in motion a chain of events that would change American history. Overhearing the conversation was William Walker. Walker wrote of the encounter for a Christian magazine. The Wyandot Methodist wrote letters about the meeting. Soon the news spread, and a mission was planned.

Jason Lee was ordained to lead that mission. In 1834, Lee traveled with a group of 70, eventually finding Fort Vancouver and John McLoughlin, chief factor for the Hudson's Bay Company. The Canadian McLoughlin was supposed to discourage settlers, but instead he was sympathetic to them. Thomas McKay, another Hudson's Bay Company employee, helped Jason Lee select a site for his mission at a place about 10 miles north of present-day Salem. Lee found Native Americans who had camped here for generations.

The work was slow, especially since Lee lacked craftsmen skilled in constructing buildings and a school. Lee went to gather reinforcements in 1837–1838. Despite a fresh influx of settlers, serious flooding at Mission Bottom caused major problems for the group, which now numbered about 50. Lee relocated his mission to an area near the present Broadway and D Streets. The mission closed in 1844, but by then a small community of settlers, along with native Kalapuya Indians, had formed.

Lee did much more than start a city. His letters, reports, and crusades were instrumental in attracting settlers to the Oregon Territory, which in turn tipped the political balance in favor of Oregon, and the entire northwestern territory, becoming part of the United States.

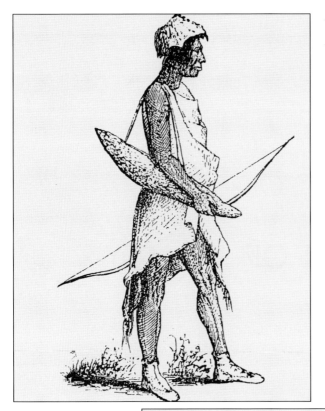

The Kalapuyas occupied the land just north of Roseburg, between it and Tualatin. The Kalapuyas were hunter-gatherers. Women did most of the gathering, while men did most of the hunting. The men wore loincloths during the warmer months and leggings or cloaks in winter. The women donned skirts or aprons of bark, grass, or animal skin. (Courtesy of University of Washington Libraries, Special Collections, NA 4005.)

This early drawing shows the general facial features of a Kalapuya male. Though not mentioned, it is likely that Lewis and Clark met Kalapuyas. The Kalapuya people were devastated by various epidemics. Today the Kalapuyas are part of the Confederated Tribes of the Grand Ronde. (Courtesy of University of Washington Libraries, Special Collections, NA 4008.)

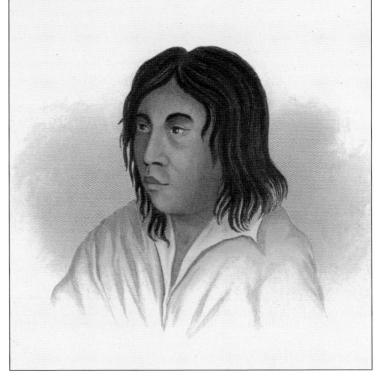

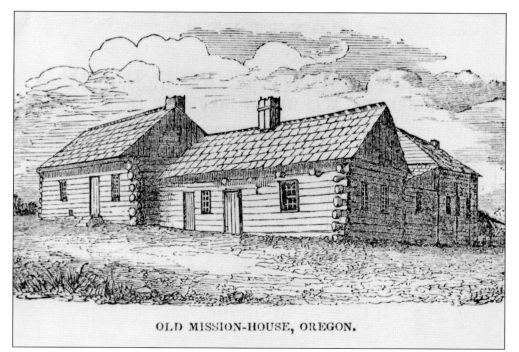

OLD MISSION-HOUSE, OREGON.

Jason Lee built his mission at Mission Bottom, a few miles north of the city of Salem. Lee came to the area in answer to the request of the Flathead Indians to learn more about "the white man's book of heaven." Lee may have decided on an area near Salem because the Kalapuya people had slightly flattened foreheads, and he may have thought they were the Flathead people. (SPL: SJ.)

Rev. Jason Lee responded to the call for missionaries to Oregon, arriving in 1834. Lee set up his mission just north of the present city of Salem. Lee lost his leadership role in the mission in 1844. He returned to Canada and died just before his 42nd birthday in 1845. (OSL.)

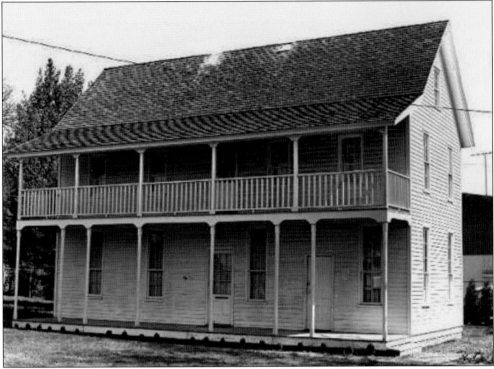

This is the Lee Mission House. The 32-foot-by-18-foot building had several sections joined together and featured a wood shake roof. The window sashes were carved by Jason Lee using his jackknife. It was originally built in 1841. It is the oldest frame building in Salem and currently sits at the Mission Mill Museum. (SPL: Kovel.)

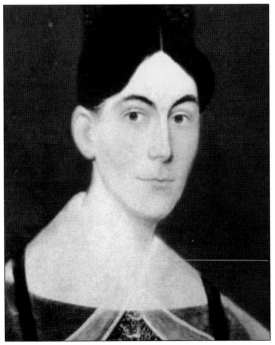

Anna Marie Pittman was born in New England but traveled by sea to Oregon to help with the Lee Mission. She married Jason Lee two months after arriving in Oregon on July 16, 1837. She died exactly 11 months later in childbirth. Reverend Lee was on a trip to the East at the time and did not return to the mission until 1840. (SPL.)

Anna Marie Pittman and her baby were buried in a single casket made by William Willson at the Methodist Mission. Her gravestone reads, "Beneath this sod, the first ever broken in Oregon for the reception of white mother and child, lie the remains of Anna Maria Pittman, wife of Rev. Jason Lee and her infant son." (OSL.)

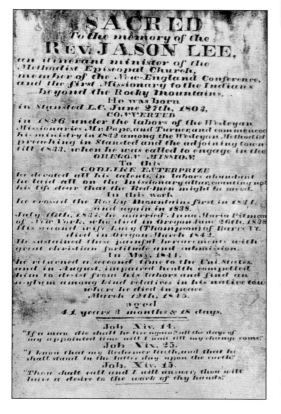

Jason Lee died on March 12, 1845. His body was moved from Canada to Oregon in 1906. His gravestone reads, in part, "To this godlike enterprise he devoted all his talents, in labors abundant he laid all on the missionary altar, counting not his life dear that the Red-Men might be saved." The grave marker is located in the Lee Mission Cemetery. (OSL: Kech.)

13

William Willson is one of two people credited with naming the city of Salem. Willson came to the Lee Mission in 1837 and assisted in constructing buildings and caring for the sick. In 1839, Willson claimed the plot of land now known as the city of Salem. He platted the city in 1846 and reportedly named it Salem because it meant "city of peace." (SPL.)

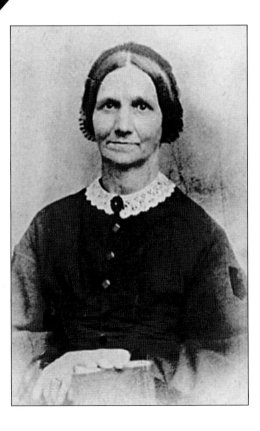

Chloe Clarke Willson ventured to Oregon in 1839 to be a part of Jason Lee's mission. She married William Willson in 1840 and was the first teacher at the Oregon Institute, later to become Willamette University, a school to teach missionaries and settler's children. Chloe was the school's only teacher for two years. (SPL.)

David Leslie was educated in the same school as Jason Lee. Leslie answered a call to assist Jason in Oregon, arriving at the mission in 1837 with his wife and children. Leslie later explored much of Washington State to the tip of Alaska. He constructed the dam and sawmill when the mission moved to present-day Salem. He also founded the Methodist Episcopal Church in Salem. (Courtesy of Marion County Historical Society.)

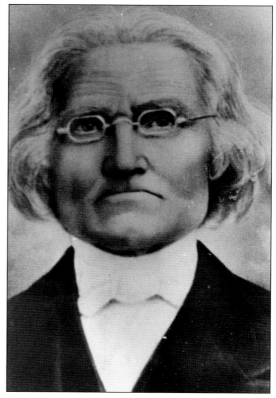

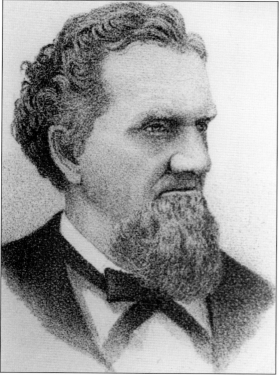

Josiah Parrish answered the call from Jason Lee to come help with his mission in 1840. Reverend Parrish was a founding member of the Oregon Institute and was part of the meetings held north of Salem at Champoeg that led to the formation of Oregon's provisional government. Parrish drove the first spike in the Oregon and California Railroad. Parrish Middle School, located on Parrish's donated land claim, bears his name. (Courtesy of Marion County Historical Society.)

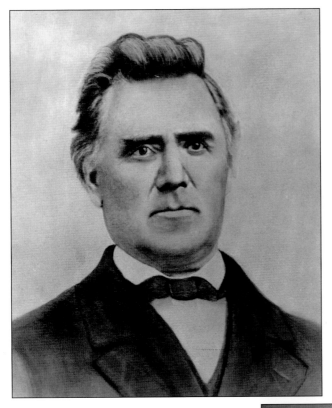

Gustavus Hines arrived in Oregon in 1840. In 1842, Hines and his wife, Lydia, took in Lucy Anna Lee, Jason Lee's daughter by his second wife (who had died shortly after childbirth). They raised the child after losing their only daughter. (Authors' collection.)

Thomas Cox arrived in Salem in 1847 with 11 wagonloads of goods that he couldn't sell from a store he owned in Jolliet, Illinois. Cox set up a store here and became Salem's first merchant. At the time, Salem consisted of only three or four houses and the mission. Cox set up his store, Judson House, near where the Capitol Towers are today. (SPL: M.)

Two

A State Capitol

Oregon's state capitol building has dominated Salem since before Oregon joined the Union. William Willson, who originally platted Salem, laid out a large public area designed to hold government buildings, including the capitol. Eventually government buildings would claim all but one block of this square. Since the beginning, the capitol has been the subject of controversy. The original building, constructed in 1853, was occupied for only a very short period of time because of an attempt to relocate the capitol to Marysville (present-day Corvallis). The attempt was ended by an act of Congress, but it didn't end the fight. The new wood-frame building burned to the ground on December 29, 1855, scarcely a month after the Oregon Legislature returned to Salem. Arson was suspected, but a formal inquiry stated that the fire was not intentionally set.

For a time, the legislature met in two downtown businesses (neither of which still exist) until a more permanent structure could be built. That too was mired in controversy. It wasn't until 1872 that the legislature appropriated funds for a second capitol building. This structure, which faced west instead of north, was completed in stages until 1893, when a large dome was added. This building stood until April 25, 1935. A fire, which started in the basement of the east wing, burned into piles of old records in wooden storage boxes. The columns that held up the dome were hollow. An updraft into those columns helped the blaze spread quickly, totally engulfing the structure in a short time. Among those who tried to rescue furniture and records was a young Mark Hatfield, who would one day become Oregon's governor and a U.S. senator.

A third capitol was constructed between December 1936 and June 1938. This modern capitol has served the state ever since. Wings have been added to provide office space for lawmakers. A 1993 quake damaged the building, and in 2008 a third fire broke out in the offices of the governor, but it was quickly extinguished and didn't spread. The governor and his staff relocated to other offices during reconstruction.

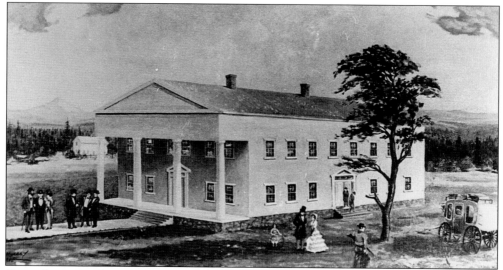

Oregon's territorial government needed a place to meet. In 1853, contractors began work on a statehouse. Lawmakers occupied the building briefly in December 1854. Shortly thereafter, the capitol moved to what is now Corvallis. Federal action forced a move back to Salem. After meeting in the statehouse for only a month, this building was destroyed by fire. Arson was suspected, but an official inquiry found against that claim. (OSL.)

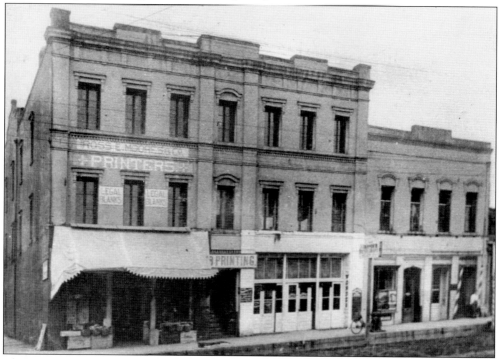

This is the Holman Building, located at 275 South Commercial Street. The Holman Building served as Oregon's capitol from 1859 until the completion of the first state capitol building in 1876. Before serving as the capitol, the Holman Building held Vic's Saloon, which was known as a meeting place for territorial legislators. The Holman Building stood until 1951, when it was demolished. (OSL.)

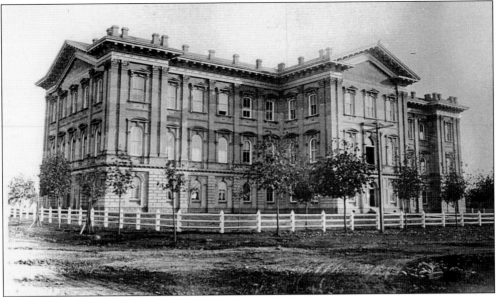

Oregon's first permanent state capitol building was started in 1873 and was completed in 1876. The building was three stories tall and held all departments of state government as well as the legislative assembly. In this picture, the building lacks the grand staircase and dome added later. (OSL.)

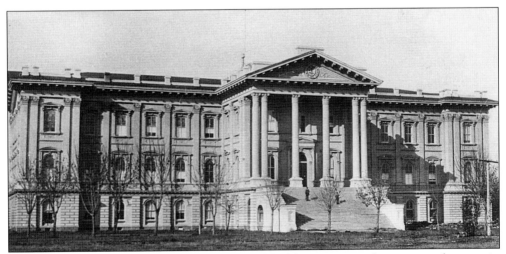

Developed in stages, the first Oregon state capitol building got a grand staircase and portico in 1887–1888. Unlike today's building, this structure faced west, towards downtown. (OSL.)

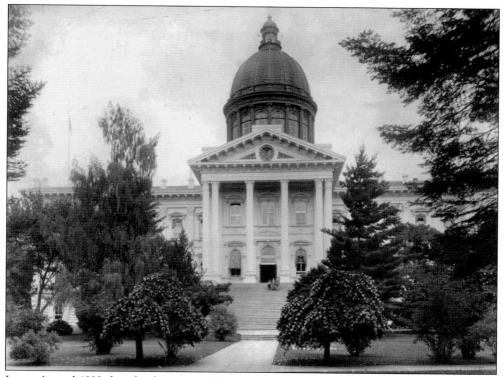

It wasn't until 1893 that the dome was added to the capitol building. The dome was copper-clad and was intended to bring light into the rotunda. The total cost of the building came in around its original estimate of $550,000. (ODOT.)

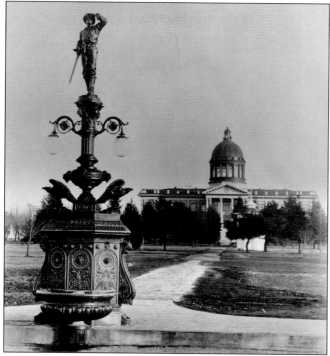

The Breyman family donated this statue in honor of Werner and Eugene Breyman, pioneers of Salem who operated businesses here, including a construction establishment. The statue is believed to be a memorial to the Spanish-American War. The old capitol building can be seen in the background to the east. The statue and fountain, added later, were placed on the National Register of Historic Places in 1989. (SPL: SCC.)

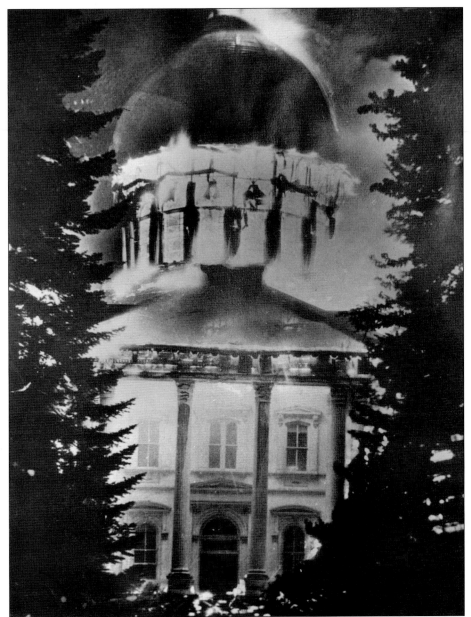

April 25, 1935, is a day remembered by many in Salem. Fire started in the basement of the capitol, possibly due to faulty electrical wiring. While many in Salem sat down to dinner, played baseball, or planned vacations, a janitor inside the capitol smelled smoke. Someone outside then reported seeing smoke. The Salem Fire Department arrived in only three minutes. Despite heroic efforts, the blaze quickly spread to piles of old records kept in wooden boxes. Hollow construction drew the fire up into the rotunda, which inverted and collapsed. The design of the building was called a firetrap by the deputy state treasurer, Fred Paulus. Paulus helped firefighters locate the most valuable records. Portraits of nearly all of Oregon's governors, however, were lost, along with almost all of the furniture. The only person to lose his life in the blaze was firefighter Floyd McMullen, who perished while manning a fire hose when a piece of the building collapsed on top of him. (OSL.)

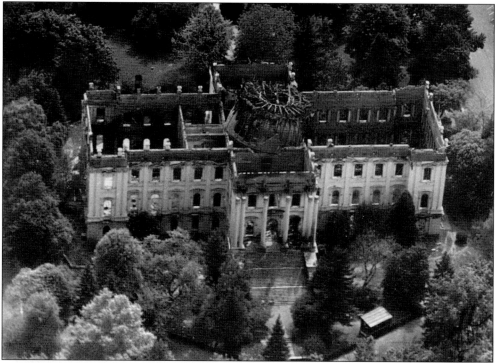

Despite the valiant efforts of the Salem Fire Department, the capitol building was a total loss, as this aerial photograph shows. The only good news out of the blaze was that most of the state's $40 to $50 million dollars in investments had been moved out of the capitol building and placed in vaults at the Ladd and Bush Bank. (OSL: Jack Sholkoff, photographer.)

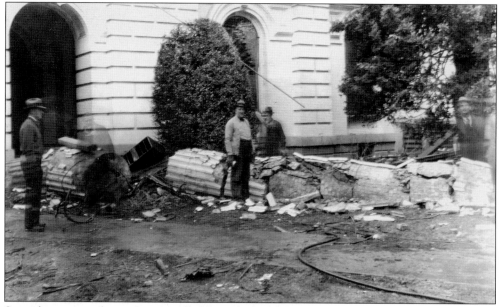

Some furniture and records were pulled from the building. Among the rescuers was a young Mark O. Hatfield, who would one day become Oregon's governor and a U.S. senator. This photograph shows one of the ruined columns of the old capitol building. (OSL.)

One of the few pieces of furniture rescued from the capitol fire in 1935 was this antique desk built between 1878 and 1885. It now sits in the office of the Speaker of the House. The desk was likely built by the department of corrections and was the working desk of Speaker Vera Katz (1985–1989). The Oregon Heritage Commission gave this desk a designation of H00001, its highest level. (Courtesy of Tom Fuller, photographer.)

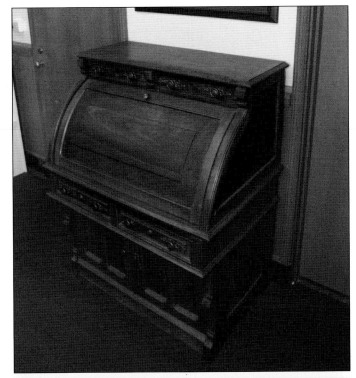

Oregon's third capitol building was constructed between December 4, 1936, and June 18, 1938. The 162-foot-wide building is covered in Vermont marble. (ODOT.)

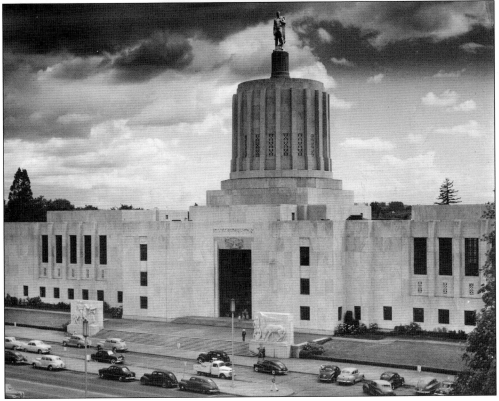

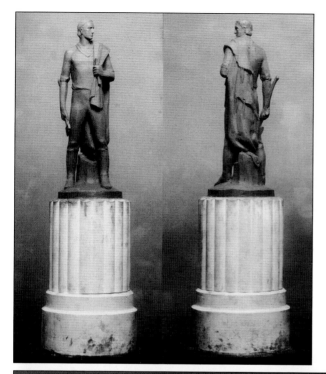

As plans for a new capitol began, artist Ulric H. Ellerhusen created the design for what has become known as the *Golden Pioneer*. Ellerhusen made this clay model before casting the 22-foot-tall statue. It was shipped through the Panama Canal, by railcar, and finally by flatbed truck to Salem, where it was installed in 1938. The statue is gilded with gold leaf. (OSA.)

A worker stands on scaffolding beside the *Golden Pioneer*. This picture was taken in the 1980s, during either maintenance or regilding of the statue. School children have collected pennies in the past to fund the maintenance of the *Golden Pioneer*. (SPL: SCC.)

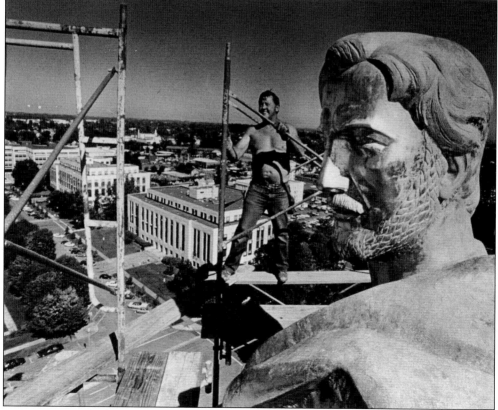

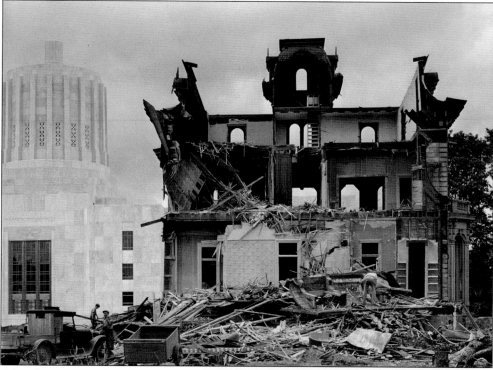

After the construction of Oregon's third capitol building, the land around the capitol was cleared of homes to make room for more public buildings and the capitol mall. The Patton house was one of the homes destroyed; others were moved. The Patton house, pictured as it appeared during demolition, was built between 1868 and 1870. (SPL: M.)

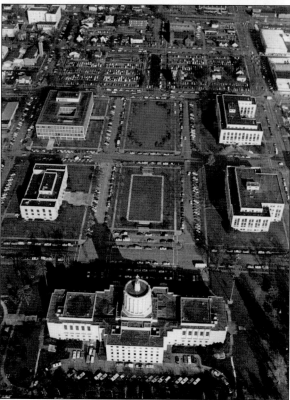

This is how the capitol mall looked in the early 1970s. The capitol building is located at the bottom of the picture, and the four main mall buildings (clockwise from lower left) are the State Library, Labor and Industries, Transportation, and Public Service Buildings. (SPL: SJ.)

25

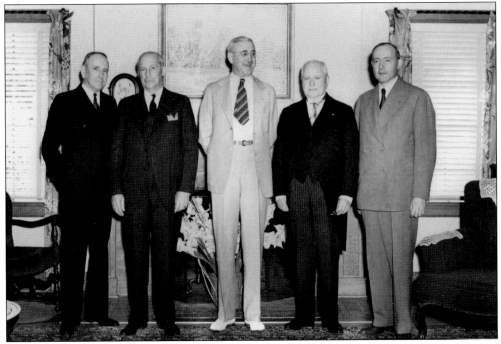

On August 3, 1940, Gov. Charles Sprague (right) held a luncheon at his home. He invited four previous governors, including, from left to right, Oswald West (1911–1915), Ben W. Olcott (1919–1923), Albin W. Norblad (1929–1931), and Charles H. Martin (1935–1939). (SPL: M.)

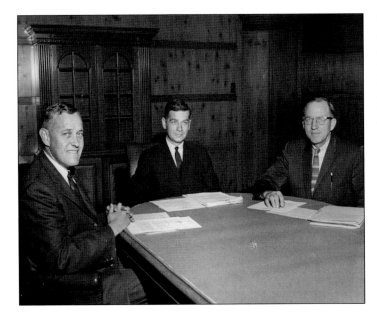

Three Oregon governors are meeting as the board of control. From left to right are Tom McCall, Mark Hatfield, and Bob Straub. The photograph was taken in the 1960s, when McCall was secretary of state and Straub was treasurer. The Legislative Assembly created the board of control in 1913 to coordinate the management of state institutions, construction of state buildings, and other duties assigned by the legislature. (OSA.)

Three

SALEM'S INSTITUTIONS

Salem has long been dominated by the presence of state government. Not only is the state capitol located in Salem, but many state institutions are as well. Salem became the place to care for those who were a danger to society or who could not care for themselves.

Prior to 1866, all convicts were housed in Portland. On May 16 of that year, they were all transferred to Salem, housed in a temporary wooden structure, and put to work making bricks for the first state penitentiary. Until the late 20th century, all prisons were located in Salem by law. Some of the most notorious criminals in Oregon history have been housed at the penitentiary, also the scene of prison breaks and riots.

Youthful offenders were also kept in the penitentiary until the 1880s, when the state legislature passed funding for a reform school for boys. The first student body of what would become MacLaren Youth Correctional Facility consisted of three boys. The facility remained in Salem until a fire destroyed it in 1927 and it was relocated to Woodburn.

State government found itself needing to care for its mentally or physically challenged citizens. In 1870, a census showed that there were at least 30 deaf children in the state. This led the legislature to provide $2,000 to establish a deaf and mute institute in Salem. Three years later, a school for the blind opened in Salem taught by Nellie Simpson, herself blind. In 1880, the legislature also provided funds to build a hospital to care for the mentally ill. The Oregon State Hospital on Center Street is one of the most recognizable buildings in the city.

Oregon State Institute for the Feeble Minded was the original name of what became Salem's Fairview Training Center. Fairview opened in 1908 with 30 patients and was closed in 2000. Salem was also home to a tuberculosis hospital that is now the location of Corban College east of town on a rise that overlooks the city.

Throughout its history, Salem has provided both physical property and staff to support these institutions.

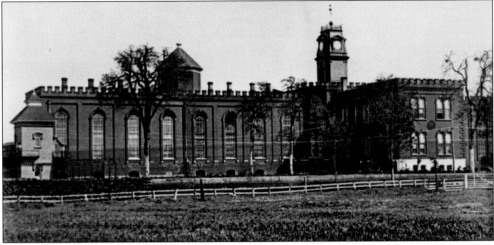

This is the Oregon State Penitentiary as it appeared in the 1880s. The facility, located at the end of State Street, is still in operation today, though the original structures no longer exist. (SPL: M.)

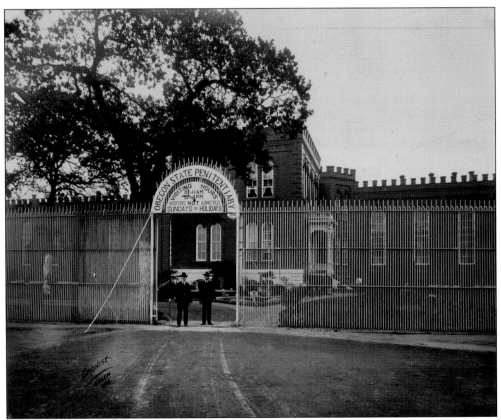

This photograph shows the entrance to the state penitentiary in 1902. The man with the cane is Warden James. According to the sign, visiting hours were 9:00–11:00 a.m. and 2:00–4:00 p.m. (SPL: GN.)

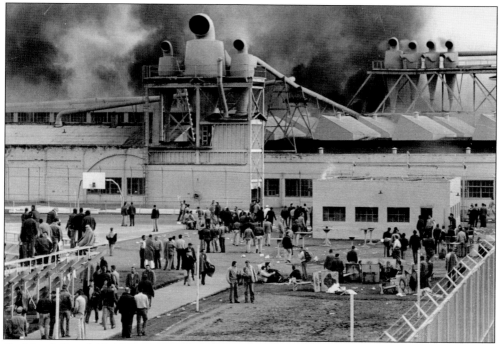

On March 9 and 10, 1968, prisoners at the Oregon State Penitentiary rioted. *Oregon Statesman* reporter Wes Sullivan was recruited on the spot to meet with the prisoners and hear their demands. Rioting prisoners gather in the exercise yard as smoke billows from an adjacent building. (SPL: SJ.)

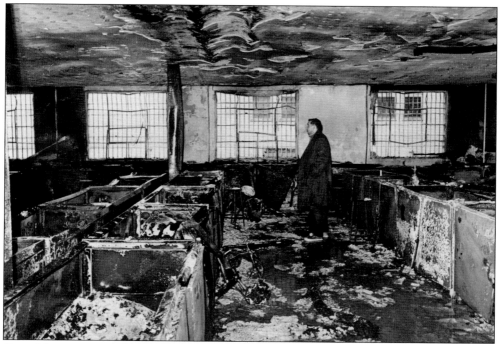

One of the areas set on fire during the prison riot was the laundry. This photograph shows damage to the ceiling, bent bars on the windows, and ruined laundry carts. (SPL: SJ.)

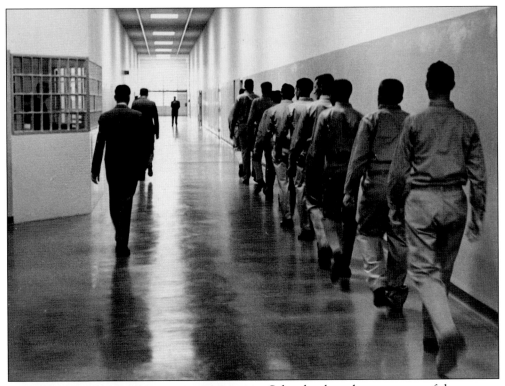

Salem has been home to most of the correctional facilities in the state. The Oregon State Correctional Institution (OSCI) was established in 1955 to hold medium security inmates. This photograph, taken in 1959, shows inmates being led down a hallway at OSCI. (SPL: SJ.)

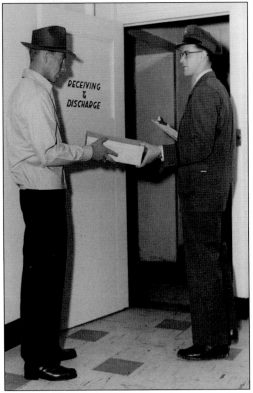

An inmate is released from the Oregon State Prison in September 1954. In those days, prisoners were handed a box containing clothing of the day and sent out onto the streets. (OSA.)

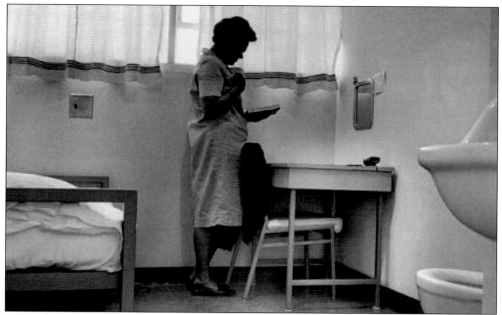

An unidentified inmate stands in her room at the Oregon State Women's Prison in 1967. The prison opened in 1965 and was located next to the state penitentiary in Salem. (SPL: SJ.)

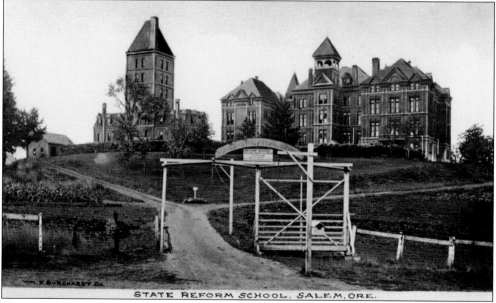

The State Reform School opened its doors on 250 acres 4 miles southeast of Salem. Each student was required to spend four hours a day in class and four hours working either on the farm or at a trade. They could study carpentry, shoemaking, engineering, tailoring, cooking and baking, painting, or blacksmithing. (OSL: Bernardi Collection.)

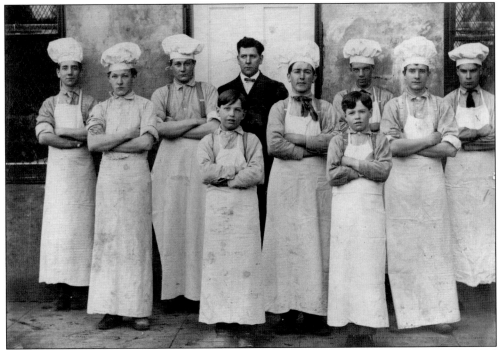

These boys, called "The Kitchen Crew," pose in hats and aprons at MacLaren School. The school was originally called the State Reform School. The name was changed to Oregon State Training School and finally MacLaren School for Boys in 1951. (OSA.)

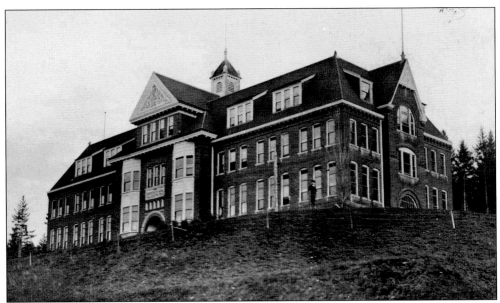

The Oregon Tuberculosis Sanatorium was the first state-owned TB hospital in the West. The first five patients were admitted to the institution in 1910. During its history, over 8,000 patients were treated at the facility, which overlooked the Willamette Valley and is the current location of Corban College. (OSL.)

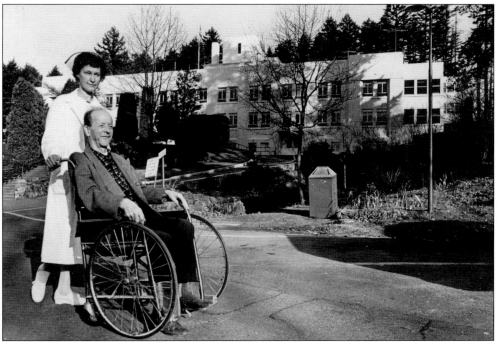

Nina Ellenburg, RN, poses with wheelchair patient W. W. Stevenson of Portland in front of the Tuberculosis Sanatorium in Salem. Over its 55-year history, the hospital employed over 3,000 doctors, nurses, and other staff to care for TB patients. (SPL: SJ.)

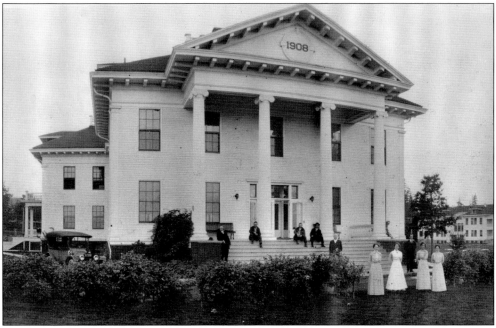

Oregon State Institute for the Feeble Minded was the original name for the Fairview Training Center in southeast Salem. It was established in 1908 by the Oregon Legislature. The year is visible on the front of the building in this picture. December 1, 1908, saw the first 39 adults and children transferred from the insane asylum. (OSA.)

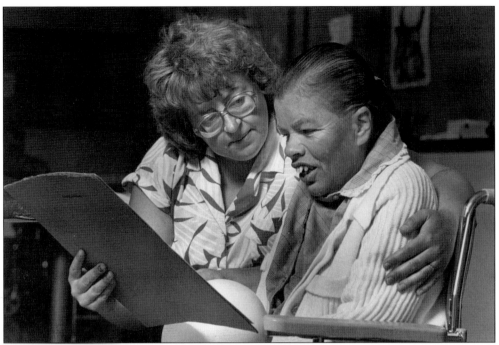

Until its closure in 2000, Fairview served the mentally and physically impaired with a variety of programs. Here a woman shows materials to a patient while comforting her with a gentle hug. (OSA.)

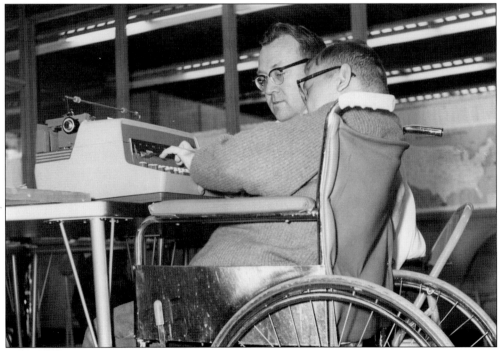

Among the programs taught at Fairview was typing. This photograph appears to have been taken in the 1950s. (OSA.)

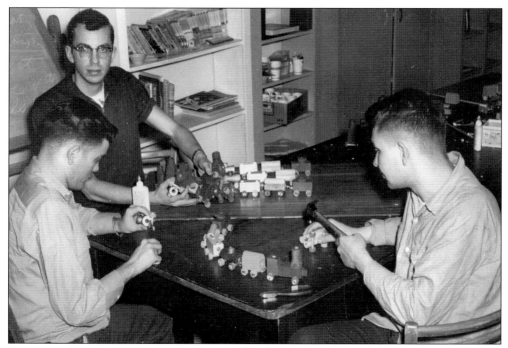

Patients at Fairview build toys in a photograph taken in the 1940s. The school did not operate free from difficulties. There were escapes and even disease outbreaks. (OSA.)

Following World War II, the programs at Fairview evolved as life expectancies increased for the disabled. The name of the facility was changed to Fairview Training Center. Several court decisions and federal inspections led to better living conditions and programs for the patients. (OSA.)

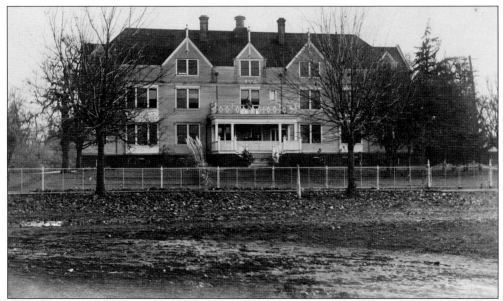

The Oregon School for the Blind sits at its third location on the east side of Church and Mission Streets. The school still operates today for 100 students on property donated by Asahel Bush in perpetuity. (OSL.)

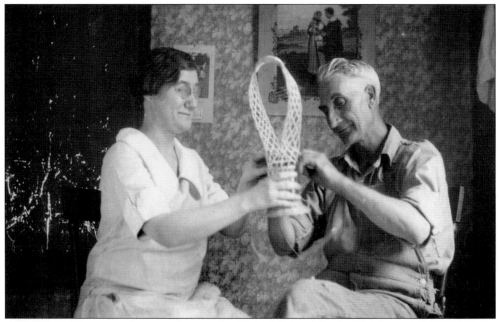

Arts and crafts were taught to students at the Oregon School for the Blind as part of a mission to provide training in self-help skills. Students, often all adults, were also taught basketry, weaving, and hammock making. (OSA.)

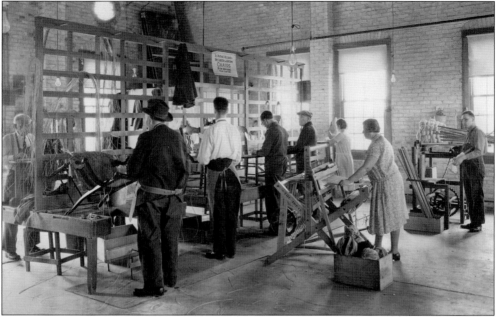

The blind school also contained a furniture and saddlery shop. In this photograph, students construct chairs. Music and debating societies were featured activities, along with an orchard and garden. (OSA.)

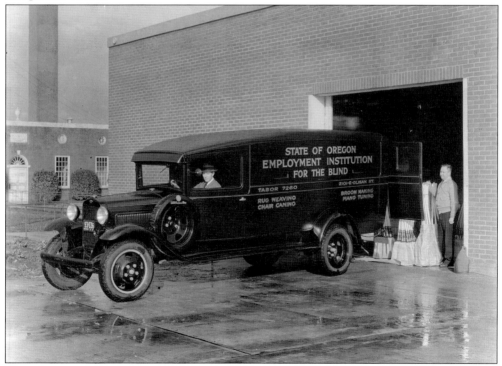

This photograph was taken in 1932 of a truck used to help further the employment of students at the School for the Blind. It advertises some of the services provided by the students, including rug weaving, broom making, chair caning, and piano tuning. (OSA.)

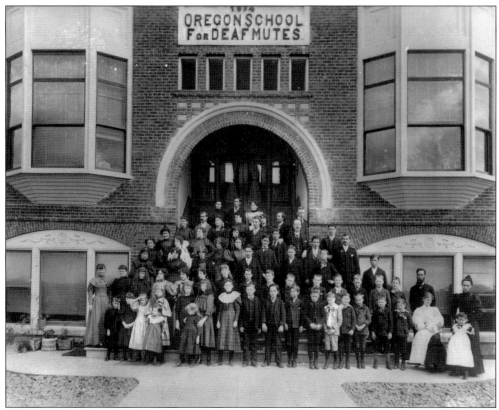

This is one of the locations of the Oregon School for Deaf Mutes east of Salem. It featured printing and carpentry shops set up to train young students. A farm and orchard were also maintained to employ the young people as well as to supply food for the school and a small income. (OSA.)

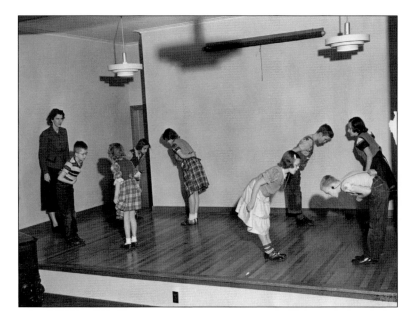

Students at the Oregon School for Deaf Mutes participate in a rhythm dance class in 1952. Teacher Betty Richardson leads students, from left to right, Gary Moss, Judy Roth, Bonnie Hensley, Bertha Ann Chrisley, Ann Homenyke, Jimmy Weiss, Shelby Candle, and Vicky Sue Hughson. (OSA.)

This photograph shows a driver's training class at the Oregon School for Deaf Mutes. (OSA.)

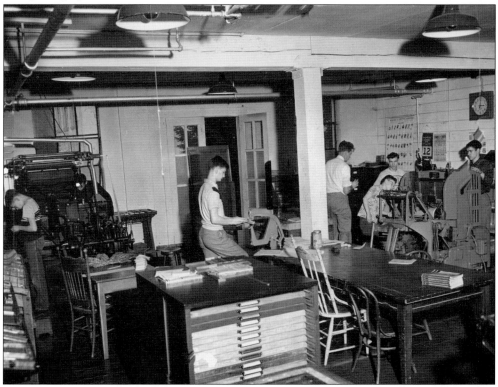

The Oregon School for Deaf Mutes was founded in 1870. In 1876 the Oregon Legislature passed a law providing a free education to all deaf persons in the state. Here deaf students study at the print shop. (OSA.)

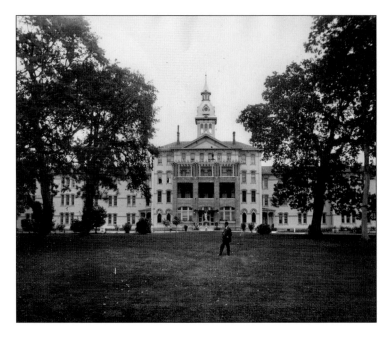

The Oregon State Hospital for the Insane was constructed in 1880 at a cost of $184,000. Three years later, 372 patients were transferred to the new facility. This photograph was taken around 1905 of what is known as the J Building. The hospital's functions included housing the criminally insane and diagnosing and treating mental illness for those who voluntarily committed themselves. (OSA.)

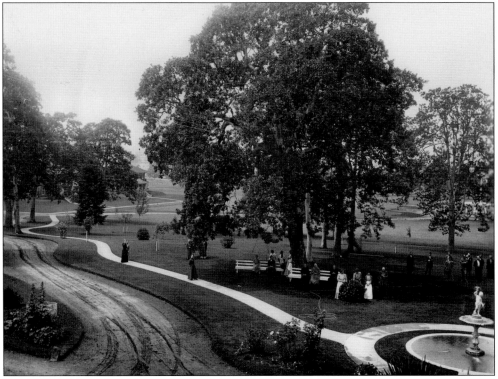

The grounds of the state hospital provided areas for patients and staff to walk and get exercise. This photograph appears to have been taken in the early 1900s. (OSA.)

Staff from the Oregon State Hospital waits for patients in this ward, which appears to be in a courtyard separated from the outside by a fence. The photograph may have been taken in the late 19th or early 20th century. (OSA.)

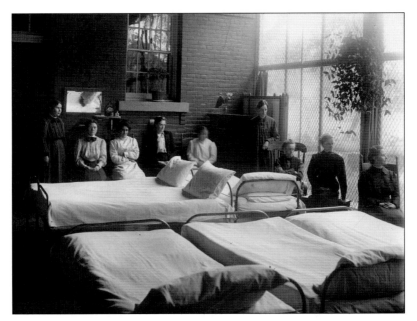

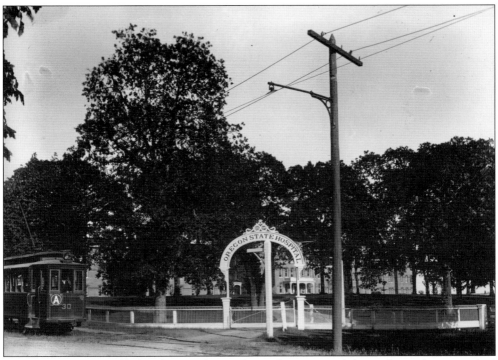

More buildings were added to the state hospital over the years until the peak population reached 3,545 patients in 1958. This photograph shows an entrance to the hospital as it existed in the very early 1900s. Notice the electric streetcar parked at the front entrance. (OSA.)

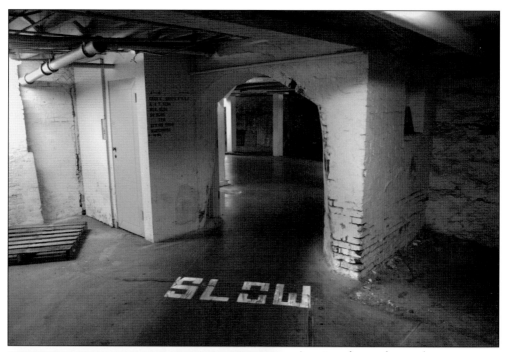

A series of tunnels runs between the state hospital buildings and the Dome Building across Center Street. This photograph shows how new tunnels were cut into the foundations of older buildings and shored up as needed. The dirt floor on the right is part of the foundation of the oldest portions of the building. (Courtesy of Tom Fuller, photographer.)

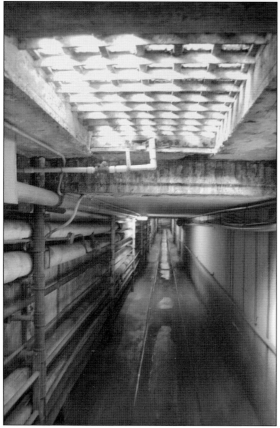

To provide light in the tunnels under the state hospital, these glass panels were installed in the ceiling. The glass, some purple, can be seen from the sidewalk above along Center Street. (Courtesy of Tom Fuller, photographer.)

Four

FAMOUS PLACES

One advantage to having state government located in Salem is the many beautiful and grand buildings constructed to house state and local institutions and government offices. In addition, Salem boasts beautiful hotels, theaters, an opera house, and ornate homes that show off the best examples of early Oregon architecture.

The old Marion County Courthouse no longer exists, and the U.S. post office was moved to a new location. At one time, these buildings formed a grand vista stretching along Court and State Streets to the old state capitol. Salem City Hall was once an immense brick structure with a large tower. It too was torn down. Salem's original hospitals also no longer exist. Salem's first hospital, in fact, was in a house. Until it burned in 1971, the Marion Hotel was an imposing part of the downtown landscape serving as a center for social life for more than a century.

Before the age of television, Salem residents would go the opera at the Reed Opera House or attend a moving picture show at places like the Vaudette, the Grand, or the Elsinore Theaters.

Some of Salem's great places were not hotels or government institutions but private homes. The Bush House and Deepwood Estate are two examples of what luxury living was like in Salem in the 19th century. The A. C. Gilbert House was home to an inventor. The Herbert Hoover home was where a U.S. president grew up.

This photograph of the Salem Post Office was taken in the 1930s. At that time, the building was located on Church Street between the old courthouse and the state capitol. In 1938, this building was moved onto the campus of Willamette University, where it was known as Gatke Hall. (SPL: M.)

These six men formed part of early Salem's mail carriers. Their shirts were part of the uniform, but apparently they could pick out their own ties. Five of the six men, known only by their last names, are Taylor, Howard, Hatch, Farrar, and Cooper; the order is unknown. (SPL: M.)

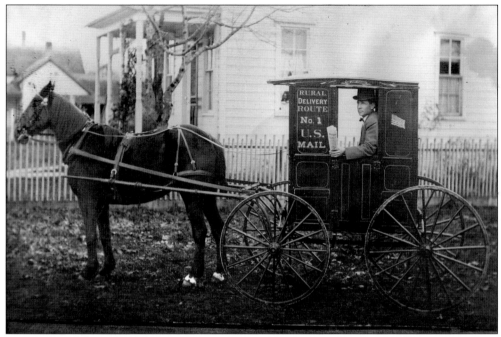

Fred Gunning drives his horse and buggy in 1907, delivering mail to Rural Delivery Route No. 1 in Salem. Fred is dressed up for the occasion in top hat and bow tie. (SPL: M.)

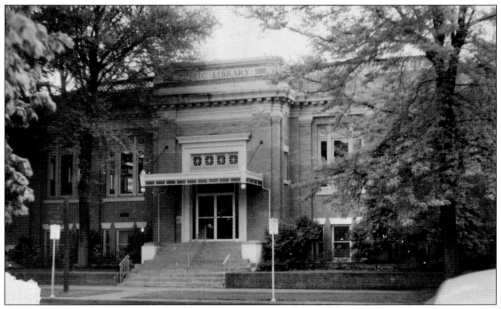

The Carnegie Library was built in 1912 using a grant from the Carnegie Foundation. It housed the public library until 1972, when the collection moved to Liberty Street. (SPL.)

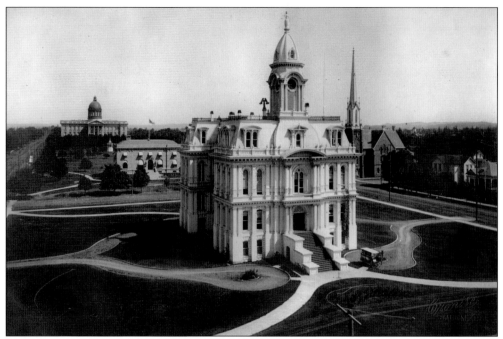

The Marion County Courthouse dominates the foreground of this photograph taken around 1903. The state capitol building sits in the background, with the federal post office between it and the courthouse. A tall clock tower topped the four-story courthouse, built in 1885. The capitol burned in 1935, the post office was moved in 1938, and the courthouse was torn down in 1952. (SPL: M.)

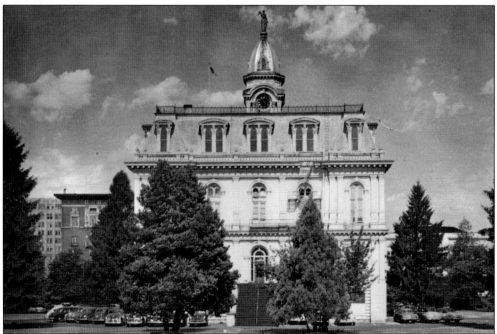

This view of the old Marion County Courthouse was taken in the early 1950s. The courthouse opened to the east, whereas its replacement has its main entrance on the west side. (ODOT.)

This is the first city hall for Salem. It was completed in 1896 and stood until 1971. Walter Pugh designed the building. Walter also designed the dome for the state capitol that burned in 1935. The old city hall was torn down because voters didn't want to pay for keeping up the historic structure, preferring to build a new civic center instead. (OSL.)

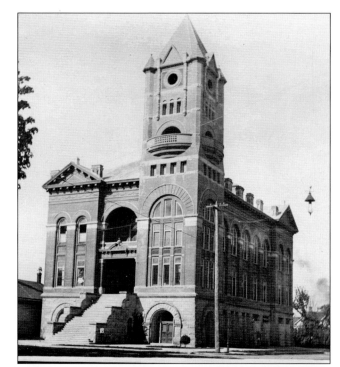

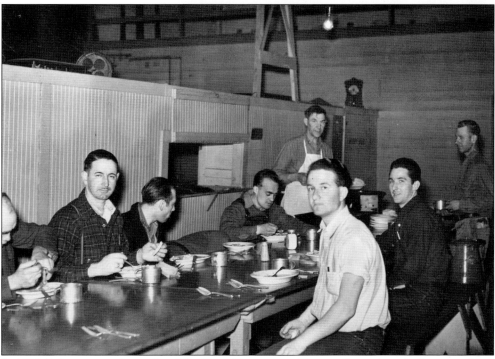

In 1938, Salem was in the midst of the Great Depression. The top floor of city hall was used as a hotel for the homeless. The police chief at the time was John Minto, descended from the Oregon pioneer of the same name. The hotel was affectionately called Hotel de Minto. The men in this picture enjoy a meal served at the hotel. (SPL: M.)

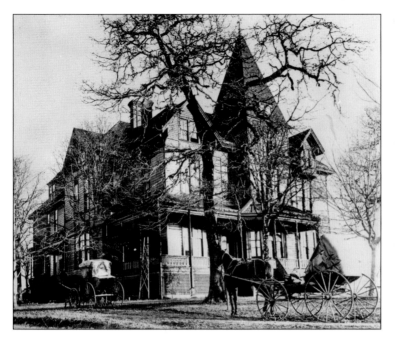

The Glen Oak Orphans Home was built in 1887 by the Oregon Children's Aid Society on 10 acres on Asylum Avenue. By 1899, other agencies were providing homes for orphans, and the attendance at this home had dropped to six, causing the state to withdraw its subsidy. The Oregon Children's Aid Society then offered this home to Salem Hospital. (SPL: M.)

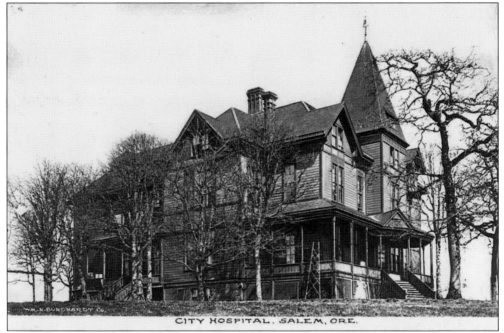

Salem City Hospital opened in January 1896 and moved into this building, next to the Oregon State Hospital, in 1900. The purchasing agreement with the Children's Aid Society required the hospital to retain three beds for indigent youngsters in need of medical treatment. The hospital operated in this building until 1916, when it broke ground at 2561 Center Street NE. (OSL.)

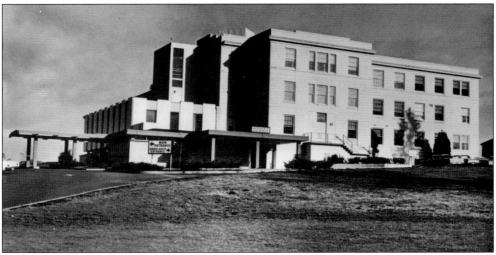

For many years, Salem had two hospitals. Salem Hospital became Salem General Hospital, pictured here, in 1927. The board of the hospital renamed it to distinguish their institution from the adjacent Oregon State Hospital. (Courtesy of Salem Hospital.)

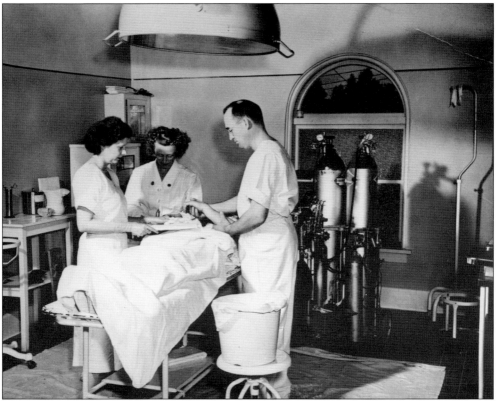

This is an early operating room at Salem Hospital. One of the reasons Salem Hospital opened was to support Willamette University's medical school. The university needed access to a hospital for some of its student programs. (Courtesy of Salem Hospital.)

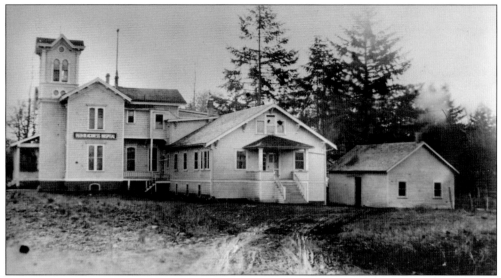

In 1916, Franz B. Wedel and four Mennonite deaconesses bought the Capitol Hotel at 665 Winter Street SE for $10,000. They established Salem Deaconess Hospital and Home. This site is the location of the current Salem Memorial Hospital. The two hospitals merged in 1969. (Courtesy of Salem Hospital.)

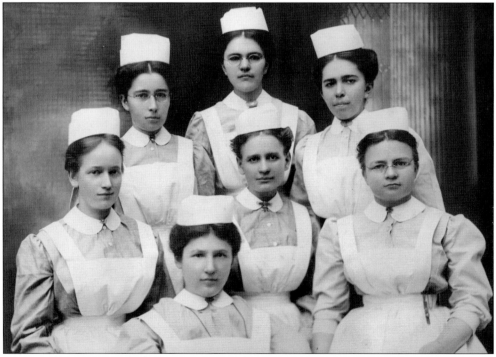

These student nurses studied medicine at the Salem Deaconness Hospital, which was in operation from 1916 to 1947. (Courtesy of Salem Hospital.)

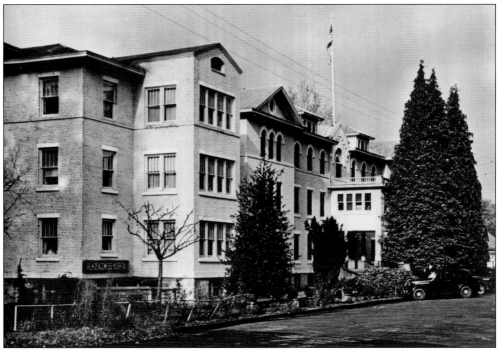

This 1935 photograph shows the Salem Deaconness Hospital. Bricks from a burned mill were salvaged and used in the construction. The building sits on the current site of Salem Memorial Hospital. (Courtesy of Salem Hospital.)

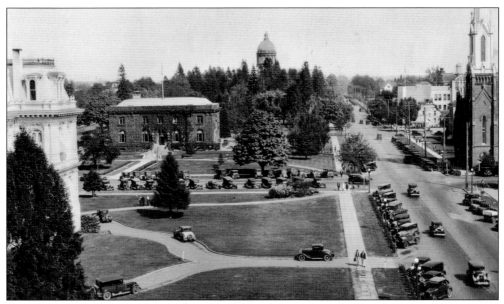

State Street is pictured as it looked in the 1930s. One can see the Marion County Courthouse just off the frame to the left, the post office in the center, and the old state capitol building in the background. (OSA.)

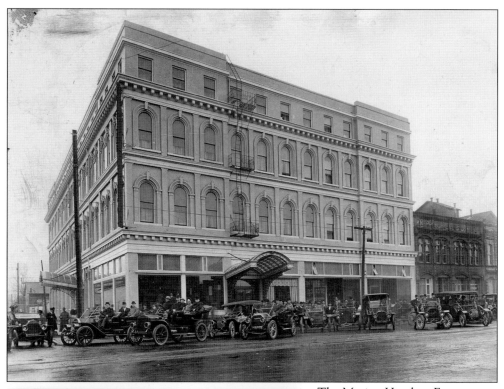

The Marion Hotel on Ferry Street opened as the Chemeketa House in 1870. The building was such a landmark that it determined the elevation of surrounding streets. (ODOT.)

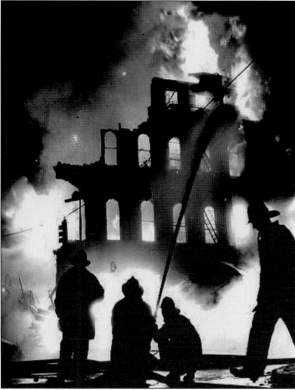

After more than 100 years of service, on November 12, 1971, the Marion Hotel burned to the ground. Firefighters tried valiantly to put out the blaze but to no avail. (SPL: SJ.)

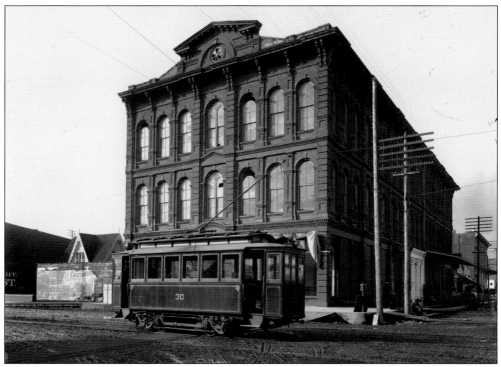

Reed Opera House is one of the only large structures remaining in Salem from the 19th century. Cyrus Reed built the opera house in 1869–1870. It became the center of early social life in Salem. Reed took a tremendous risk building a 1,500-seat theater when Salem's population at the time was only around 1,300. (OSL: Trover Collection.)

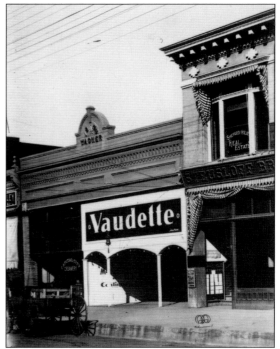

This 1906 picture shows the Vaudette Theater on Court Street. It was among the first storefront movie theaters in Salem and sat next to a real estate office. After the Vaudette opened its doors, nickelodeons sprang up and closed in astonishing numbers, mainly due to the fact that a store could easily be converted to a movie theater. (SPL: M.)

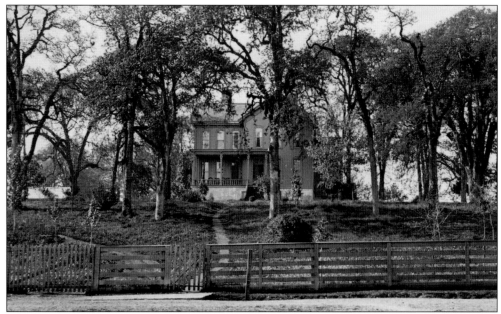

Asahel Bush bought 100 acres from David Leslie, one of Salem's founders, in the 1870s. Bush built this house in 1878 at 600 Mission Street. The house sits on a rise once known as Rattlesnake Hill. It included indoor plumbing with hot and cold running water, gaslights, central heating, and 10 carved marble fireplaces. The grounds also included a greenhouse, the oldest in Oregon. (SPL: SCC.)

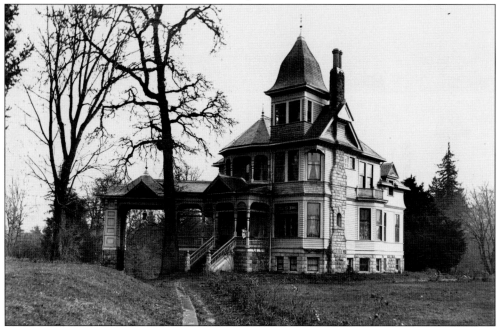

Deepwood Estate was built in 1894 for Salem druggist and land speculator Dr. Luke Port. It launched the career of architect William Knighton, who later served as Oregon's first state architect. The house sits on a 5-acre estate that today includes a nature walk. This early photograph, taken before the carriage house or gardens, features an unidentified young girl sitting on the porch railing. (OSL: Trover Collection.)

Andrew Gilbert had this house constructed in 1887, and it is one of the only historical homes left in the downtown core area of Salem. Andrew was a banker until 1891. His nephew, A. C. Gilbert, invented the Erector Set. Today it is part of the Children's Discovery Museum next to the Willamette River. (SPL: Kovel.)

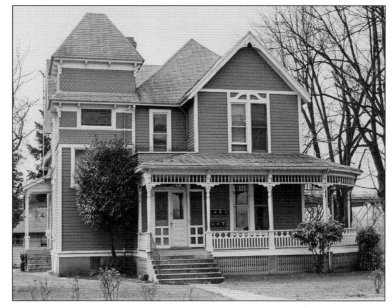

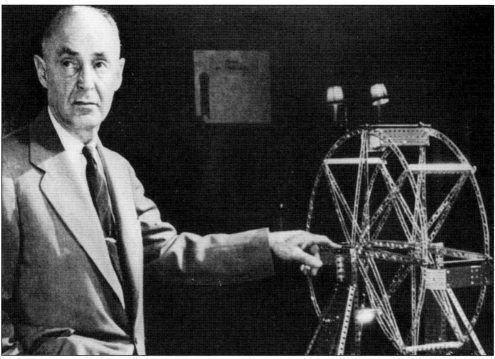

Alfred Carlton Gilbert plays with his most famous invention, the Erector Set. Gilbert was born in Salem in 1884. He attended Tualatin Academy and eventually won an Olympic medal in the pole vault in the 1908 Olympics. After inventing the Erector Set, Gilbert also created a chemistry set and a microscope. (Courtesy of A. C. Gilbert's Discovery Village.)

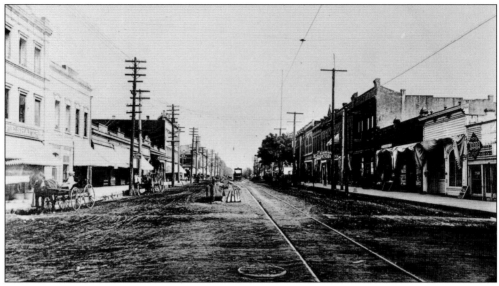

A horse and wagon pull up to the store of F. E. Shafer (left) in this scene from Commercial Street at about Ferry Street in 1905. The dirt street features a single railcar line down the middle. (SPL: M.)

This home, located at the intersection of Highland and Hazel Avenues, was the home of Herbert Hoover from 1888 until he attended Stanford University in 1891. Hoover became the 31st president of the United States (1929–1933). At the time this picture was taken, the house was abandoned and run down. (SPL: M.)

Five

THOMAS KAY WOOLEN MILL

Thomas Kay arrived in Salem in 1888. Kay had worked in the wool industry since before he was a teenager. At 51, Kay thought it was high time he opened his own woolen mill. He bought the old Pioneer Oil Company property near Twelfth Street for its waterpower. Kay pledged $55,000 of his own money to the project but needed help to open up a woolen mill. In less than a month, 352 Salem residents pledged an additional $20,000. The Thomas Kay Woolen Mill opened for business in March 1890.

Seven years later, the mill burned to the ground in less than two hours. Despite a lack of adequate insurance, the mill reopened thanks to an additional $25,000 raised by the citizens of Salem in just one night.

Four generations of Kays ran the mill until it closed in 1962. To Salem, it was more than just an employer. As Thomas Kay III explained, "To them it was an important part of living, as opposed to just a place to work." Families carried on the tradition of working at the mill, generation after generation. More than a job, it was a family. It wasn't always easy, though. There were disagreements and misunderstandings. There was even a strike. But there were also years of prosperity.

When the mill finally closed, Thomas Kay III realized the importance of the factory as an historical artifact. The mill and property was purchased by the Mission Mill Museum Association, a private nonprofit organization formed in 1964. The mill today looks very much like workers are just on a lunch break. Photographs and displays explain the process of making wool and the history of the mill. In addition, the museum also houses the Jason Lee House, the Parsonage, the John D. Boon House, and Pleasant Grove Church, dating from the 1840s and 1850s and restored and furnished in period style.

Thomas Lister Kay founded the Thomas Kay Woolen Mill with support from his wife, Ann, and the Salem community in 1889. Kay began working in mills in England when he was 10. Eventually he immigrated to Oregon and worked in the Brownsville Woolen Mill, becoming a partner in the business before leaving to found a mill of his own. (Courtesy of Mission Mill Museum.)

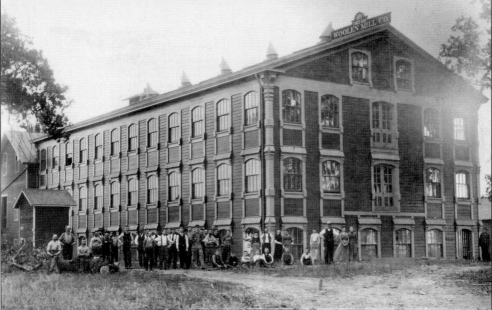

This is a rare photograph of the original Thomas Kay Woolen Mill building constructed in 1889. A dye house, two wool warehouses, and the office completed the factory. The main building was equipped with the latest equipment, the newest innovations, and the finest-quality machinery. Seven years later, the Thomas Kay Woolen Mill burned to the ground. The main mill structure was destroyed in less than two hours. (Courtesy of Mission Mill Museum.)

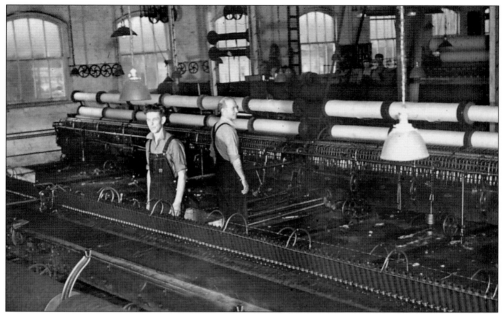

Unidentified employees work the Mill's spinning mules. Spinning is the action of twisting together wool fibers to make yarn. The simplest spinning implement is a spindle with a weight (whorl) at its end. The Thomas Kay Woolen Mill had several spinning mules on its third floor. The wool carding machines were also on this floor, and there were 30 or so looms operating directly below. (Courtesy of Mission Mill Museum.)

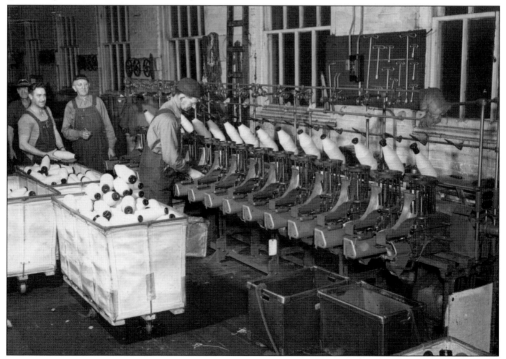

Workers remove spun yarn and add new bobbins on the Mill's third floor. (Courtesy of Mission Mill Museum.)

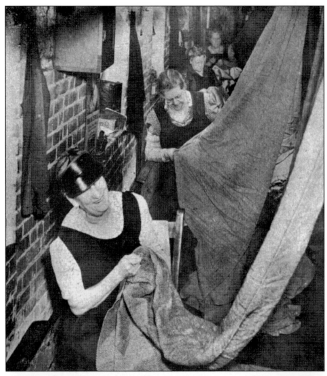

Mending was a part of the process in which defects were corrected or marked for further work. The menders, always women, actually rewove yarn into fabric where any threads were missing. They labored in poor lighting, using window light when possible to correct the flaws. (Courtesy of Mission Mill Museum.)

Mill employee Edgar Hawley cleans one of the mill's wool carding machines. These wire-covered carding rollers combed and untangled the wool fibers. The web of wool that formed was separated at the end of the process into discrete strips of roving that were ready for spinning into yarn. (Courtesy of Mission Mill Museum.)

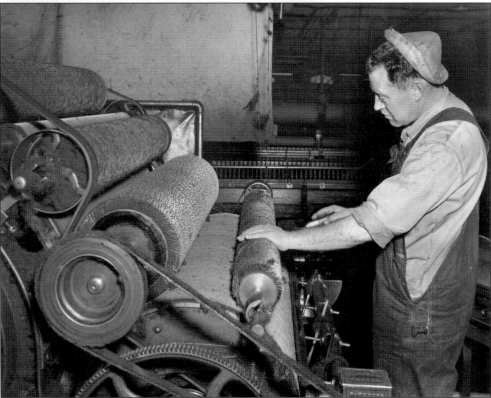

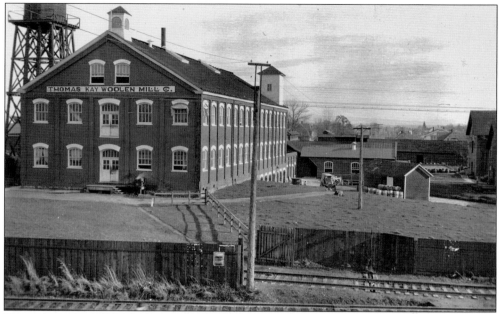

This is how the mill looked around 1910. The selection of the site for the mill was strategic, in that it was vital for the building to have close access to the trains. Trains would bring raw wool to the mill and were used to ship the finished fabric out. (Courtesy of Mission Mill Museum.)

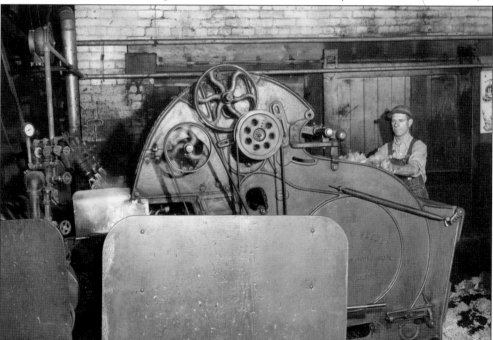

Loren Chamberlain puts wool into the feeder of the Curtis and Marble Machine Company blending picker in the mill's picker house. Here raw fleece was picked clean of all debris. The jobs carried out in the picker house were considered lower-skilled positions. Many employees, including future mill owner and manager Thomas Kay III, had to spend time working in the picker house before taking on more skilled work. (Courtesy of Mission Mill Museum.)

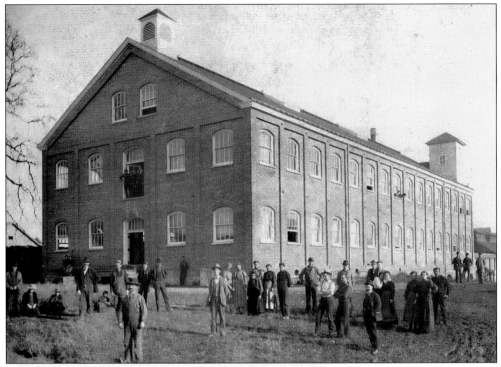

Some employees stand in front of the Thomas Kay Woolen Mill in the early 1900s. (Courtesy of Mission Mill Museum.)

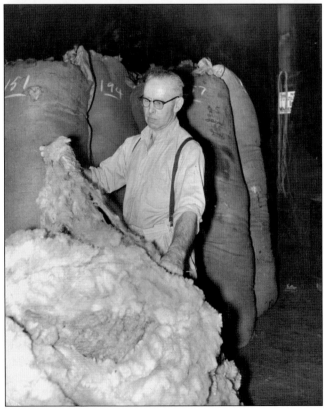

An unidentified mill employee works in the wool warehouse. Fleeces were delivered to the mill's wool warehouse in large bales. This employee was tasked with sorting the raw wool by color, fiber length, and texture. (Courtesy of Mission Mill Museum.)

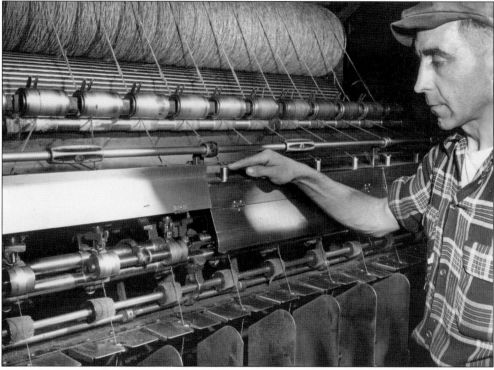

Ernst Van Burn works on one of the mill's spinning mules. The spinning mule twists the strands of roving (which are structurally weak) into yarn (structurally much stronger) as it moves in one direction and winds in onto the bobbins on the return. (Courtesy of Mission Mill Museum.)

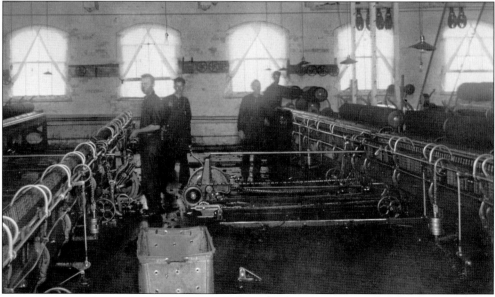

The spinning mule was the first spinning machine used at the Thomas Kay Woolen Mill. With 336 bobbins, the mule produced about 1,400 pounds of yarn each day. Spinning frames were added in the 1940s that allowed for the faster production of yarn, which were needed for the increased orders the mill was filling for the U.S. Armed Services. (Courtesy of Mission Mill Museum.)

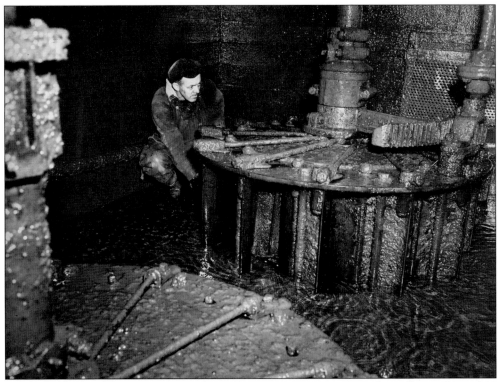

Millwright Wayne Mentzer works on the mill's turbine. As water from the millrace plunged 12 feet, it poured through the upper turbine gates, turning the shaft; then the water dropped out of the discharge cylinder and flowed away downstream. The turbine was installed at the mill in 1914. The water that powered the mill's turbine traveled a 19-mile canal from the Santiam River in Stayton to Salem. (Courtesy of Mission Mill Museum.)

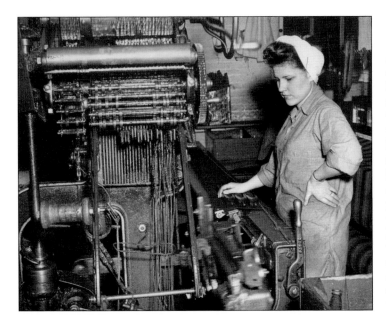

A worker monitors one of the mill's automated looms. Unlike other mill workers, who were paid by the hour, weavers were paid by piecework; that is, they were paid by the number and quality of finished pieces of goods. This was designed to help keep the quality of the goods high and to enforce concern for the finished product. (Courtesy of Mission Mill Museum.)

Steam drifts off a dye house vat while P. G. Olds and Harry Smith pole the wool as it colors. The dye house was hot, steamy, and smelly. Workers had to have enough arm strength to pole the fleece, circulating it in the dye vats, and to remove the heavy loads as they finished. Rumor has it that some of the Saturday shift workers actually bathed in the dye vats. (Courtesy of Mission Mill Museum.)

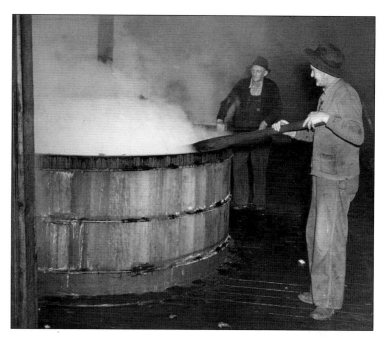

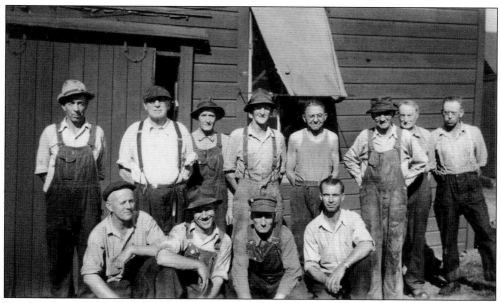

Dye house workers take a break to pose for a picture in the 1950s. Dyes and chemicals were mixed by hand and had to be accurate. Chemical dyes were used and personally mixed by the dye master, and this job was one of the most important at the mill. Walter Reid worked as the mill's dye master for many years, as did his father before him, and he is in the back row, second from the left. (Courtesy of Mission Mill Museum.)

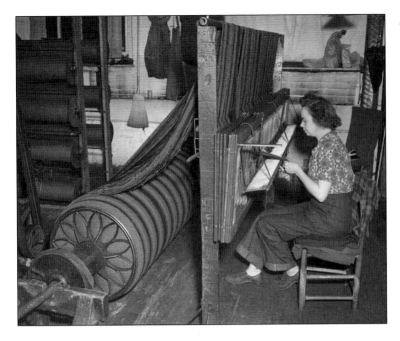

Once designed, a sample is created, and the pattern is drafted onto a card. The person "drawing in" (as seen in this photograph) uses the card as a guide to determine the order in which threads and groups of threads must pass. Once in the loom, the harnesses raise and lower groups of threads, determining fabric pattern. (Courtesy of Mission Mill Museum.)

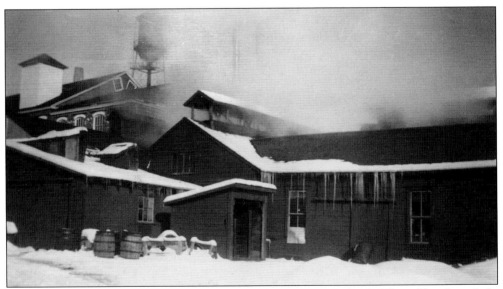

The dye house and scouring room are pictured here in the winter of 1950. The cold and poorly lit picker house created hard conditions for the workers, who had to become used to wearing layers of clothing and straining their eyes in the dim light. They would often escape to the warmth of the dye house, which was nearly always hot and steamy, for a short break from chilly weather. (Courtesy of Mission Mill Museum.)

Six

COMMERCE AND BUSINESS

A mission and a calling may have started the community of Salem, but business and commerce transformed it into a thriving city. Good soils attracted farmers and food processors. A navigable river encouraged stern-wheelers to transport goods and passengers. One of the first enterprises sold agricultural goods to California gold miners. These goods went out on the *Hoosier*, which traveled up and down the Willamette between Eugene and Oregon City.

Soon agricultural and logging products shipped out from Salem to international markets. Food processing plants and a woolen mill provided lots of jobs, so Salem's population grew. To service the growing population, other business sprang up, like bakeries, laundries, and livery stables.

To help keep the peace in Salem's growing community, a police force formed in 1885. Initially it consisted of just three officers. Even as late as 1915, the department had only seven policemen.

Paper production and flour mills were located near the river. In addition, meatpacking plants, hop dryers, and flax processing plants flourished for a time. Individual businesses also did well. The first store in Salem was opened by Thomas Cox, who brought his goods over the Oregon Trail. Joe Bernardi opened a plumbing shop, Charles Bishop started a clothing establishment, and Asahel Bush began publishing a newspaper and founded a bank. For a time, Salem supported a thriving brewery industry. One company, the Salem Brewery Association, produced Salem Beer until the city voted to go dry in 1913. The company then moved its operations to Portland.

The arrival of the telegraph and rail service increased communication and transportation options for Salem businesses. Bridges across the Willamette allowed industries to more easily ship products west. Gideon Stolz opened Salem's first cannery in 1879. Stolz didn't preserve fruits and vegetables but canned cider. His cider and vinegar works was Salem's largest and most important early business dealing with the manufacture and preservation of food products. Other canneries followed, including the Salem Canning Company, which produced tomatoes, peas, corn, beans, cherries, black raspberries, plums, pears, and apples.

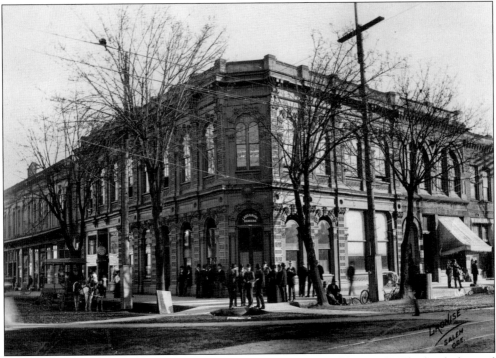

Asahel Bush founded Ladd and Bush Bank with William S. Ladd in 1867. The bank, located at State and Commercial Streets, opened in 1869. It was the first bank in Salem, which had a population of 2,000 at the time. On April 1, 1869, the bank had four deposits totaling $1,400. In 1940, the bank became part of U.S. National Bank. This photograph was taken in 1891. Groups of men are gathered on boardwalks outside the bank. (SPL.)

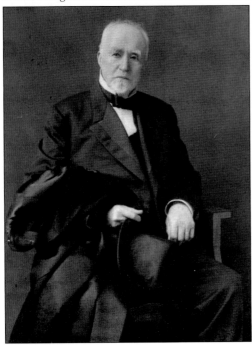

Asahel Bush came to Oregon in 1850. He founded the Ladd and Bush Bank, was active in politics, and was named state printer in 1859. Bush also created the *Oregon Statesman* newspaper. (OSL: Bush Estate.)

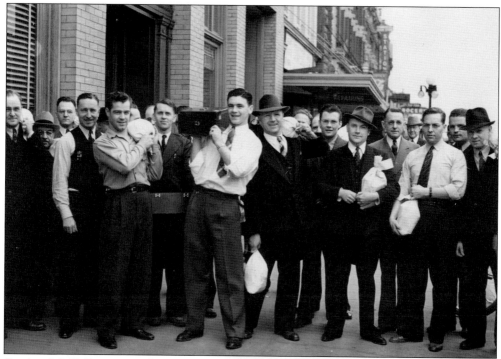

On April 6, 1940, a group of men move bags and boxes of money between the U.S. National Bank and Ladd and Bush Bank in Salem. (SPL: M.)

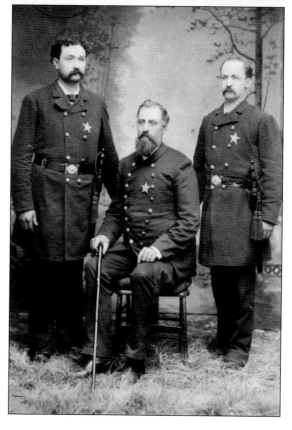

The Salem Police Department in 1885 consisted of only three officers. Pictured here are, from left to right, James Mead, M. G. "Mode" Harbord, and Leon Smith. (SPL: M.)

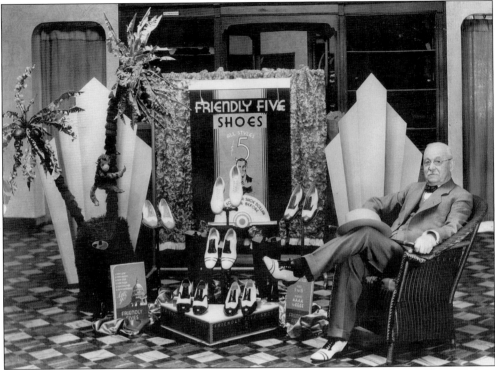

C. P. Bishop poses in his men's clothing and shoe store, advertising Friendly Five Shoes. Bishop was a well-known Salem mayor, state senator, and trustee for Willamette University. (OSL: Trover Collection.)

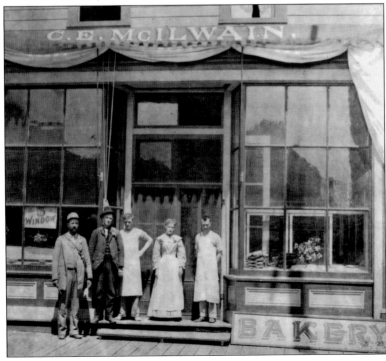

Curtis McIlwain's California Bakery was located on the west side of Court Street near Commercial and Liberty Streets. It was built in 1843 as only the third home in Salem. This photograph was taken in 1895 and shows baked goods in the windows and the staff gathered on the front porch. (SPL: M.)

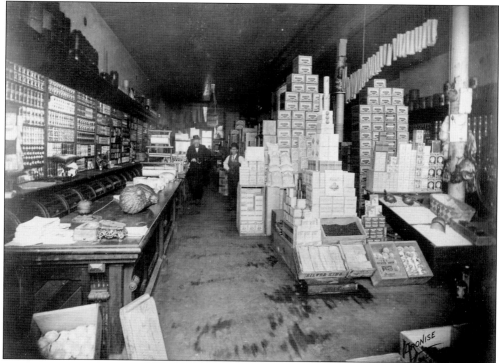

This is what a typical grocery store looked like in Salem in the 1880s. This store was owned by John Hughes and was located on State Street just west of Liberty Street. In addition to groceries, John carried seeds, flour, feed, lime, paints, oil, glass, woodenware, crockery, building materials, and wallpaper. (SPL: GN.)

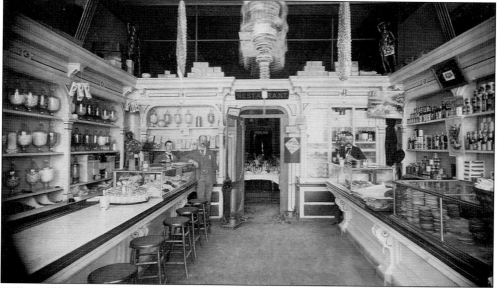

William Westacott (the taller man) and William Irwin stand behind the counters of Strong's Restaurant at 271 South Commercial Street. This photograph was taken around 1890. Amos Strong owned the restaurant, which can be seen behind the "Restaurant" sign in the back of the room. The glass jars probably held baked goods. (OSL.)

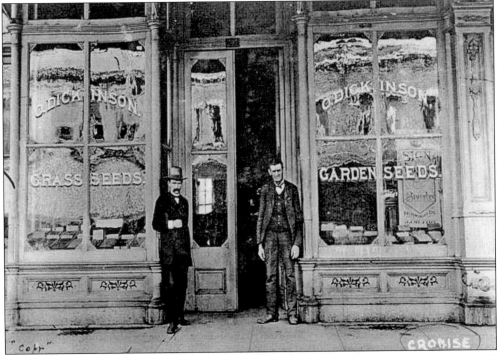

Dickinson's Seed Store was located at Commercial and Chemeketa Streets. O. Dickinson stands on the right, next to Rev. Robert Whitteker. It is possible that Dickinson is the Reverend Obed Dickinson, a former pastor who taught against slavery and openly welcomed African Americans into his congregation. Obed left the ministry in 1867 and started a successful seed business. (SPL: M.)

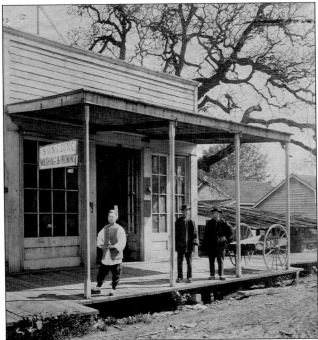

The Sung Lung Chinese Laundries shop on the corner of Court and Liberty Streets is pictured in 1888. The owner, Sung Lung, stands outside his establishment. Marion County had 360 Chinese in 1890. The Exclusion Act of 1892 closed immigration of Chinese people to the United States, and a population decline began in the 1890s. (OSL.)

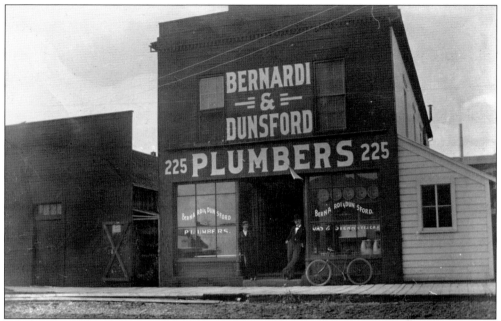

Joe A. Bernardi and George E. H. Dunsford's plumbing business was located at 225 Liberty Street in 1890. Joseph Bernardi was the son of Oregon pioneers. He had his plumbing business in Salem until he retired in 1941. (OSL: Bernardi Collection.)

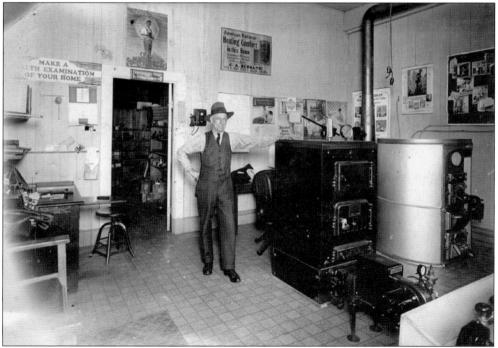

Joe Bernardi stands proudly in his plumbing store on Liberty Street in this undated photograph. Joe lived until June 23, 1952. During his life, he collected choice wines and cars, he fished, and he was apparently an avid photographer. His photograph collection was donated to the State of Oregon. (OSL: Bernardi Collection.)

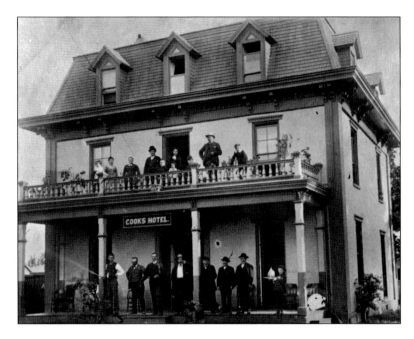

Cook's Hotel was the first brick hotel in Salem. It was built in 1864 on the corner of State and High Streets. It was torn down in 1926 to make room for the Bligh and Elsinore Theaters. It was first known as Monroe House, then Cook's Hotel, and finally Hotel Salem. This photograph was taken around 1890. (SPL: M.)

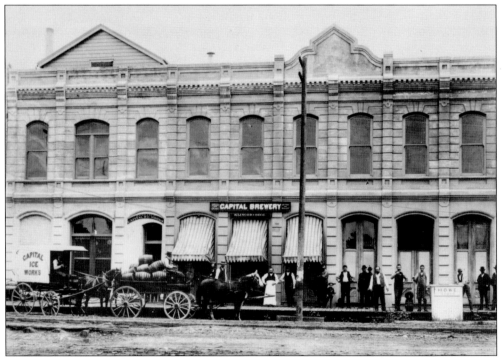

Sam Adolph started the first brewery in Salem in 1862. The Salem Brewery burned in 1869, so Sam joined with some employees, Maurice Klinger and Seraphin Beck, and started Capital Brewery at 174 Commercial Street. When this picture was taken in 1898, Klinger and Beck were listed as proprietors. The brewery mainly produced draught beer but also had a small bottling plant behind this building. (SPL: M.)

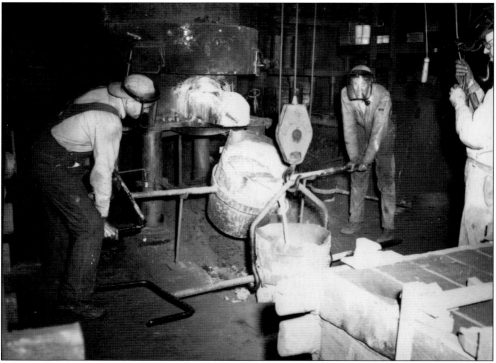

This photograph from the Salem Iron Works in 1956 shows workers pouring molten iron from one ladle into another. The men wear headgear and sheaths to protect them from the heat. Salem Iron Works was built in 1860 at the corner of Front and State Streets and employed 12 men who turned out machinery, engines, and various castings. (SPL: M.)

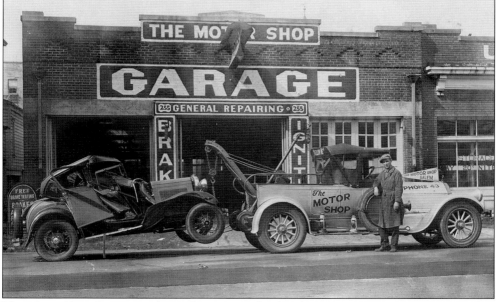

The Motor Shop Garage was located at 267 North Church Street in 1930. G. A. Coffey and S. M. Hays ran the shop. Parked out front is a 1926 Pierce Arrow wrecker towing a wrecked 1930 Ford Model A coupe. (OSL: Trover Collection.)

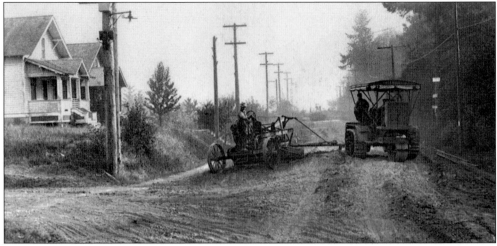

A crew works to pave one of Salem's streets between 1910 and 1915. The city began paving streets in 1907 with five blocks of Court Street. Paving became a necessity after the arrival of the first automobile in 1902. (OSL: Trover Collection.)

Pres. Herbert Hoover worked here in the State Insurance Building as an office boy during his time growing up in Salem. Hoover worked for his uncle, Henry John Minthorn, president of the Oregon Land Company. The building was located at Commercial and Chemeketa Streets. (OSL: Trover Collection.)

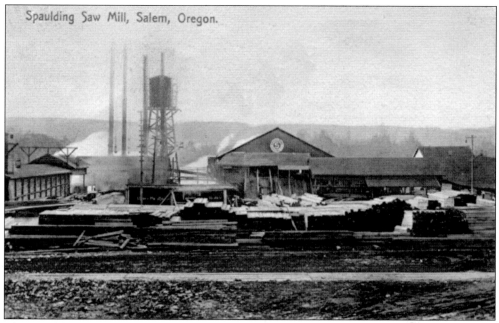

Spaulding Saw Mill, Salem, Oregon.

The Spaulding Logging Company Mill was located at Trade and Ferry Streets. The Spaulding Company got its timber to the mill mainly on tributaries of the Willamette but used overland routes as needed and even owned two steamboats, the *City of Eugene* and the *Grey Eagle*. (SPL: Ed Culp Postcard Collection.)

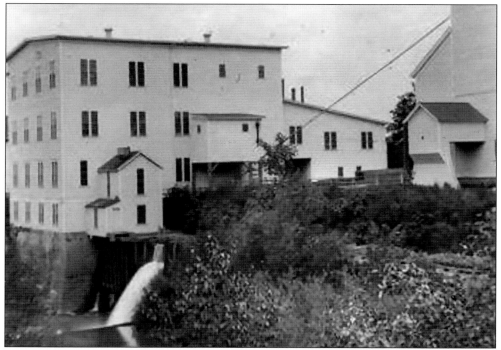

The date of this picture is unknown, but it is of Salem Flouring Mills Company. In advertisements, the company's Wild Rose Flour was called "the secret of good bread." The mill was built on a bank of the Willamette in 1865. At one time, the mill produced 400 barrels of flour a day. (OSL.)

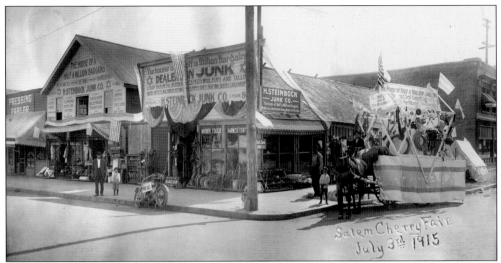

The northeast corner of Commercial and Chemeketa Streets in 1915 shows a float in the Salem Cherry Fair. To the left, one can see several businesses, a pressing parlor, and a junk company that proclaims, "The House of a Half a Million Bargains." (SPL: M.)

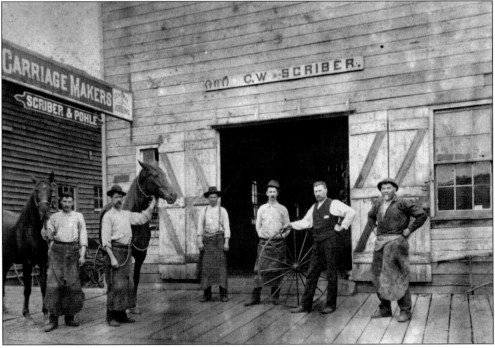

Herman and William Pohle and Charles W. Scriber were blacksmiths in early Salem. This photograph shows Herman Pohle holding the wheel at their carriage-making shop. The photograph was taken in the 1890s. (SPL: M.)

The existence of several breweries in Salem in the mid-1800s led to the growing of hops, a key ingredient in beer. In 1896, there were 10 hop growers in the Salem area. Hops were also used as fertilizer. This photograph was taken in 1939. (SPL: M.)

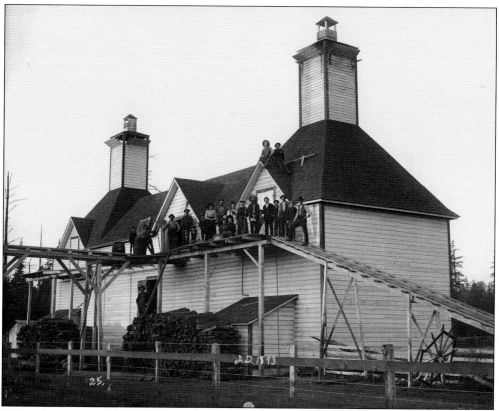

Drying hops was an important part of the brewing process. This 1893 photograph shows a three-story hop kiln. Firewood is stacked along the building to provide the heat source. The hops were transported into and out of the dryer using the ramps. (OSL: Trover Collection.)

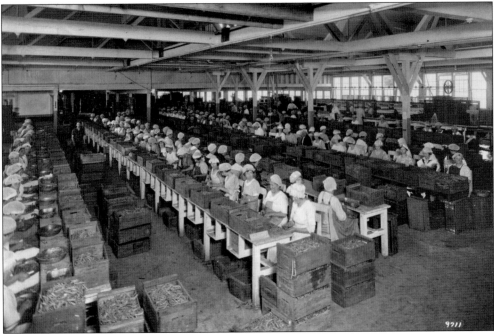

Workers prepare stringless beans at the Salem's King Products Company in 1922. During World War I, this plant provided green beans, berries, and plums for the armed forces. For the next 55 years, this cannery churned out canned peaches, plums, strawberries, green beans, cherries, and pears. (Courtesy of Truitt Brothers, Inc.)

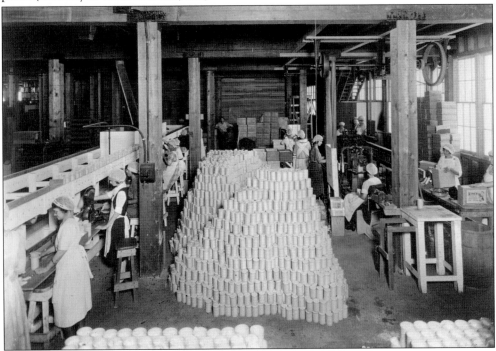

King's Food Products Company Plant on Front Street originally operated as a dehydrating plant. Here employees fill cartons with dried berries in 1922. (Courtesy of Truitt Brothers, Inc.)

This is the receiving dock for King's Food Products in 1922. In 1923, farmers began planting a variety of green bean known as Blue Lake. The bean became so popular that it captured 30 percent of the market. (Courtesy of Truitt Brothers, Inc.)

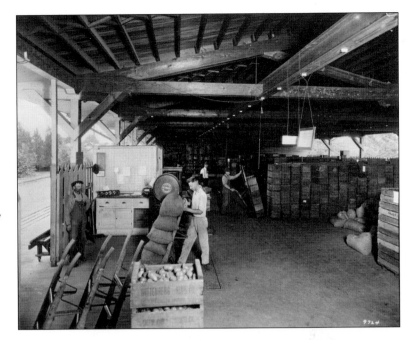

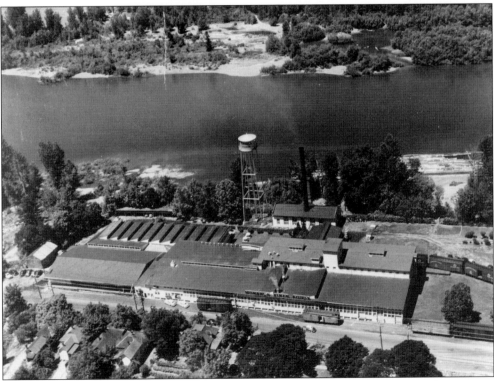

This is an aerial view of the Reid-Murdoch Division of Consolidated Foods in 1949. The company was at one time the largest wholesale grocery distributor in the United States. This plant on Front Street began canning rhubarb in May 1930, employing 50 to 60. The plant also processed apricots, Hawaiian pineapple, and green beans. (Courtesy of Truitt Brothers, Inc.)

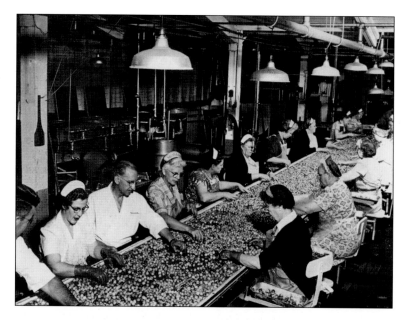

Salem is known as the Cherry City. One of the reasons for this is cherry processing plants like this one. Workers in this 1952 photograph sort Royal Anne cherries. (Courtesy of Truitt Brothers, Inc.)

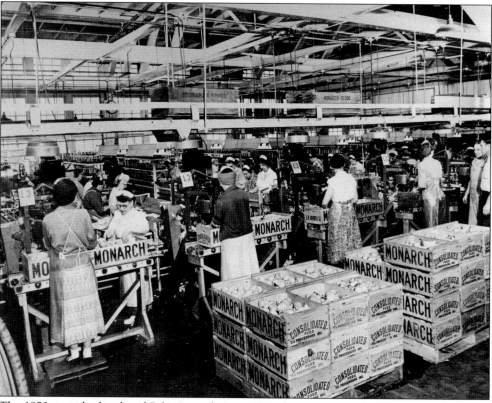

The 1950s saw the height of Salem's production of food for canning. The city was home to no less than 10 processing plants. Here workers process Monarch Foods pears in 1954. The cannery began freezing berries in the 1960s, but by the 1980s berry production waned as California began to dominate the berry industry. (Courtesy of Truitt Brothers, Inc.)

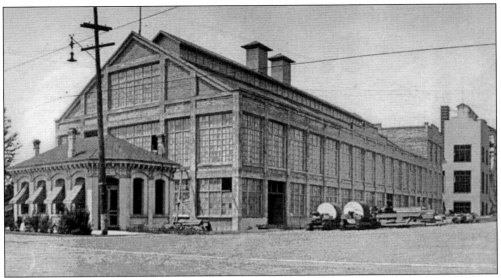

The Oregon Pulp and Paper Plant was built in the 1920s. The building was located at Trade and Commercial Streets. At one time, it was the largest employer in Salem except for the state government. Paper produced at this plant was distributed as far east as Chicago and to Mexico, South America, Asia, Africa, and the Pacific Islands. (SPL: M.)

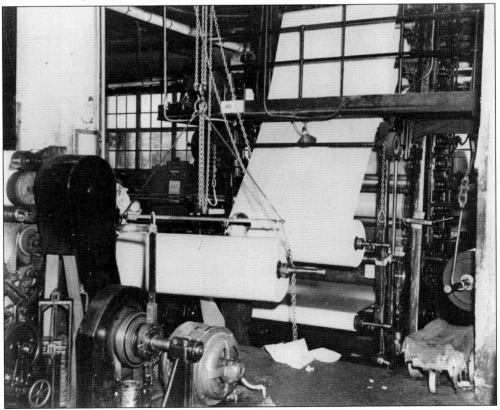

This photograph shows part of the operation of the Oregon Pulp and Paper Plant around 1940. (SPL: SCC.)

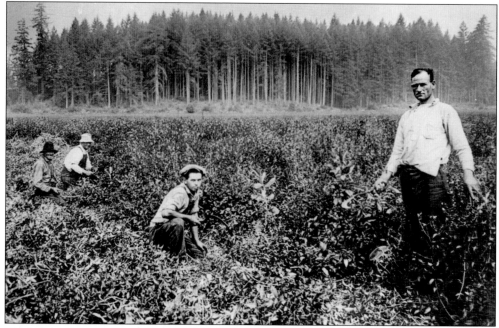

The Salem area contains a number of different soil types. Peat, which is decaying organic matter, provides a great growing medium for things like peppermint. The Lake Labish area contains this type of soil. It extends for about 9 miles near the Chemawa Indian School. This 1930s photograph shows workers handpicking peppermint. (OSL: Works Progress Administration.)

These three young ladies enjoy a soda pop in the midst of a hop field in 1930. (OSL: Trover Collection.)

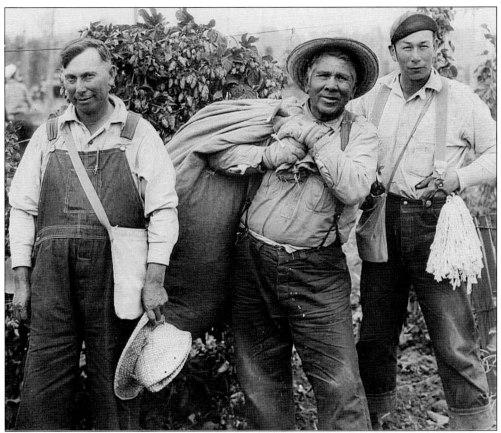

At one time, the Willamette Valley grew half the hops produced in the United States. During picking season, whole families would travel to the Salem area, bringing their children and even the family dog. The family would live in a tent or small cabin supplied by the grower. In this 1930s photograph, a crew of three harvests hops grown in shoulder-high rows. (OSL: Trover Collection.)

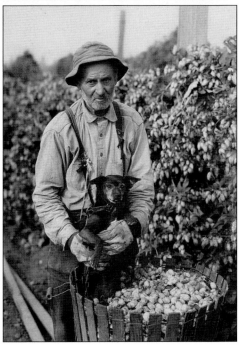

A man carries a dog into the hop fields during harvest. This Depression-era photograph is one of many that capture the hop industry when it was still very manual. Men like this one would live in "hop yards," which were more like small towns, complete with camp store and home-grown entertainment like boxing matches or Saturday night dances. (OSL: Trover Collection.)

The production of flax began in Salem in 1844, when Joseph Holman opened Pioneer Oil Works. Though the industry had many false starts and setbacks, flax from Salem was used to make linen, fertilizer, rope, twine, rugs, and fishing tackle. In this 1939 photograph, a crew harvests flax from a Salem field. (OSL: Works Progress Administration.)

Prunes were first planted in 1890 on the hills south of Salem in the Liberty, Sunnyside, and Rosedale areas. Prunes were harvested in early September by migrant pickers who lived in one-room shacks provided for them. In this 1937 photograph, two pickers gather prunes and put them into tin pails. Prune trees were shaken and the prunes picked up from the ground. (OSL: Works Progress Administration.)

Seven

TRANSPORTATION

Jason Lee and his missionaries traveled to Salem mostly by foot and canoe. The Willamette River provided an excellent means of transportation of goods, mail, and people. Keelboats and later stern-wheelers plied the waters, even helping rescue people stranded when the Willamette flooded. The ships had names like *Claire* and *City of Salem*. Ferries also crossed the river before bridges were built. Some of those ferries still operate today.

Settlers roughed out a few roads to Salem, which allowed stagecoaches to travel to and from the new city, charging a fare of only $1.

As the population grew, railroads arrived. Soon streetcars helped transport people to the train depot and around town. The Capital City Streetcar was a popular means of transportation at the end of the 19th and beginning of the 20th century. The company even had a 30-year lease to operate on Center and Commercial Streets northward to the city limits. The streetcars gave way to buses by the 1930s.

As the automobile arrived, so did the need for paved roads. The city began paving the community's streets in 1907, with five blocks of Court Street as its first project.

Salem's first airport was a racetrack at the state fairgrounds. Dr. H. H. Scovell flew the first plane around Salem and the state capitol in 1910, twenty years before the airport was built. Another major transportation milestone was the beginning of airmail and air passenger service, which began in 1941 with service from United Airlines.

Even after the railroad came through Salem, a stagecoach line still served the city. The line left from Chemeketa House and traveled to Dallas, Perrydale, Knoght's post office, Independence, McCoy, and Macleay. The fare was $1. Notice the man with the gun standing next to the stagecoach. After 1909, no more stage lines ran out of Salem. (SPL: SJ.)

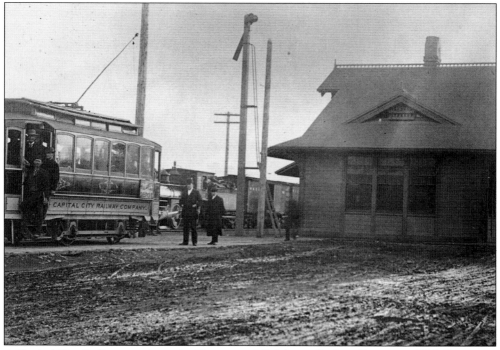

A Capital City Railway car sits at the Oregon and California Railway Station in 1893. Streetcars were a popular mode of transportation in the late 19th and early 20th centuries. (SPL: M.)

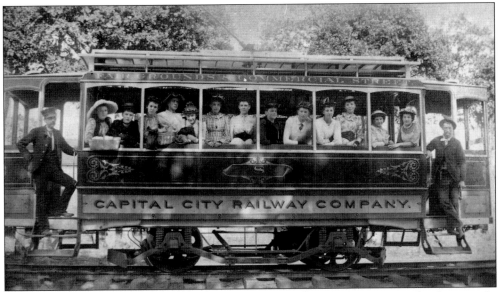

Thirteen teenage girls take the Capital City Railway streetcar to a picnic at the fairgrounds. This particular car ran between Commercial Street and the fairgrounds and is pictured in 1894. (SPL: M.)

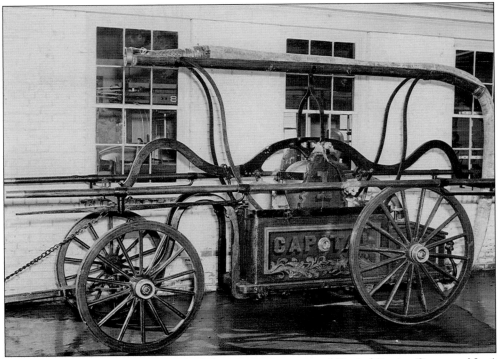

In 1865, this was a state-of-the-art firefighting apparatus, part of Capital Engine Company No. 1 (originally called Webfoot Engine No. 1). This was a hand pumper. Crews had to drag the pump to the fire and hand-pump water to put out the blaze. (OSL.)

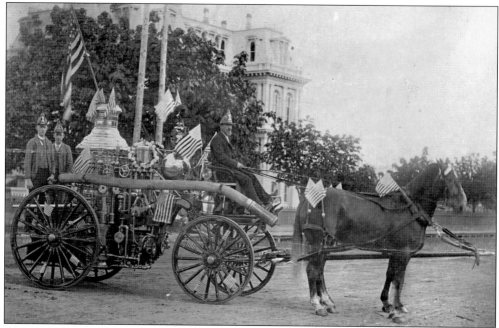

Although the date of this photograph is unknown, it features a steam pump, first introduced to Salem in 1893. The steam pump was pulled by a team of horses. No longer were large crews of men needed to pull hand pumpers. Thus a 220-man volunteer force was reduced to 14 paid firefighters. (SPL: M.)

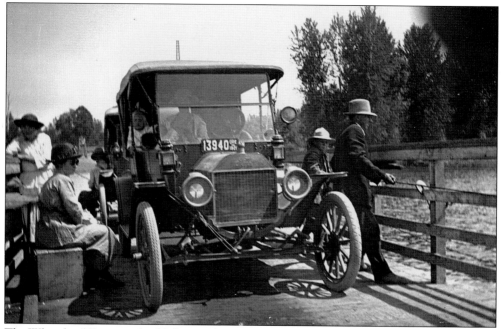

The Wheatland Ferry north of Salem is where Jason Lee first established his mission in 1834. The mission eventually moved south to Salem, but ferryboats used the area to cross the Willamette. This photograph was taken in the summer of 1921 as passengers and cars crossed the river on the ferry. It is still in operation today as one of the few ferries that still cross the Willamette. (OSL.)

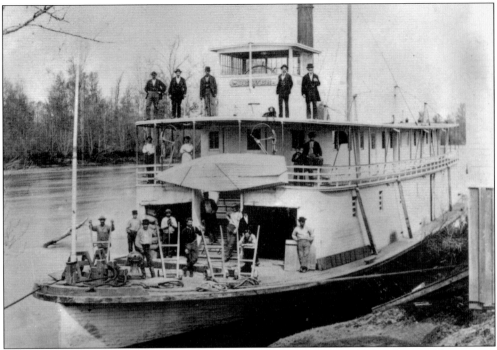

One of the reasons stern-wheelers were so popular was their shallow draft. They could maneuver in water where heavier boats could not. The steamboat *Beaver* plied the Willamette between 1873 and 1878. In this photograph, one can see men on deck with hand trucks used to load and unload freight. (SPL: M.)

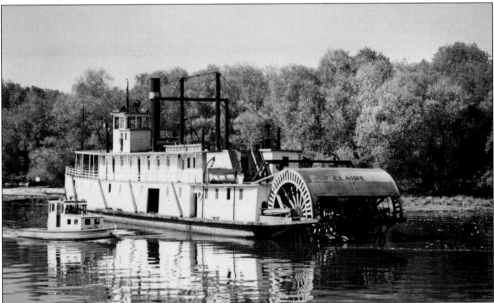

Steamboats were a vital part of Salem's transportation during its early years as a community. In this picture, the stern-wheeler *Claire* is seen on the Willamette next to a smaller vessel. Steamboats carried cargo and passengers and also went on rescue missions. During the 1861 flood, a stern-wheeler rescued 40 people from the mouth of Pringle Creek. (SPL: M.)

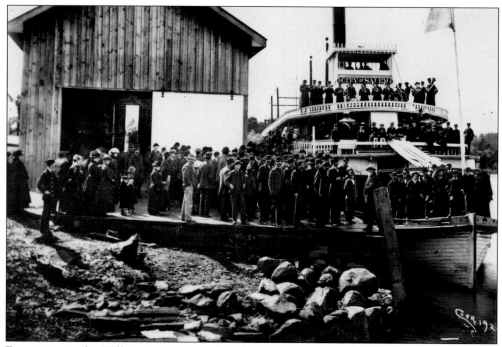

Excursions on the Willamette were popular when the river was high enough. Here crowds wait to board the stern-wheeler *City of Salem*. Steamboats ran between Portland, Salem, Albany, and even Eugene. The trip to Portland took the entire day. The *City of Salem* was built in 1875 and was used on the river for 20 years. (SPL.)

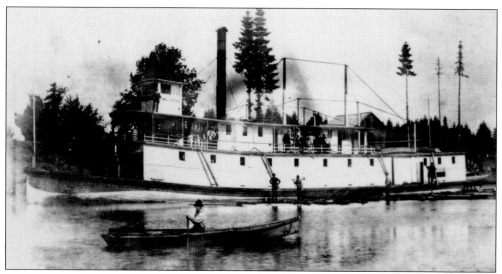

The stern-wheeler *Three Sisters* began two-day runs between Portland and Corvallis in 1886. The ship laid over for the night in Salem. It was dismantled in 1896. (SPL: M.)

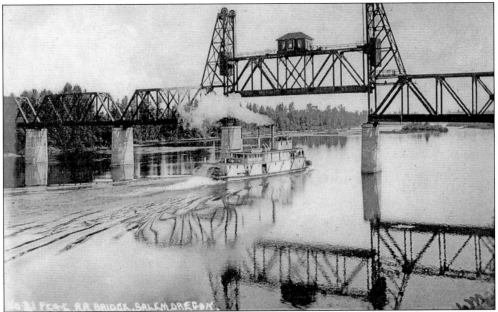

Stern-wheelers ran up and down the Willamette River on a regular basis. Here one passes under the raised middle portion of the Portland, Eugene, and Eastern Bridge, built in 1912–1913. (SPL: M.)

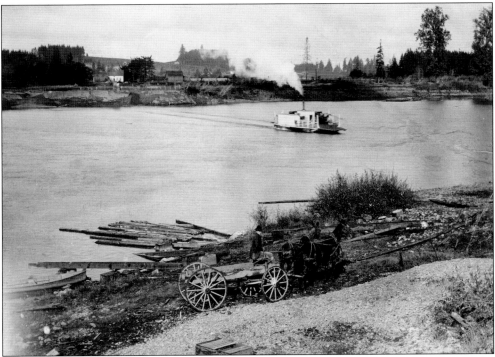

Before bridges crossed the Willamette River, ferries like the Holman's Steam Ferry plied the waters, moving goods and people back and forth. The view in this photograph, taken in the 1880s, looks towards Polk County from Salem. A horse-drawn flatbed wagon sits in the foreground. (SPL: M.)

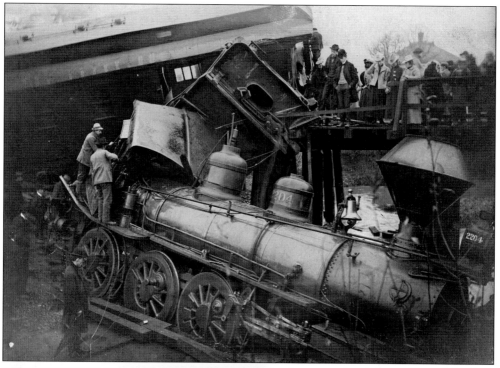

A tampered switch was blamed for this train collision near Salem on December 7, 1901. One engineer and one fireman were killed in the wreck, which took place just south of the Southern Pacific train depot. (OSL: Regina West.)

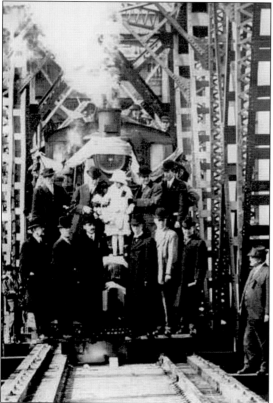

A group of men and women celebrate the opening of the Dallas–Falls City Bridge on March 13, 1913. This bridge crossed the Willamette River and was built by the Salem Falls City and Western Railroad Companies. This was also the year West Salem created its city charter. (SPL: M.)

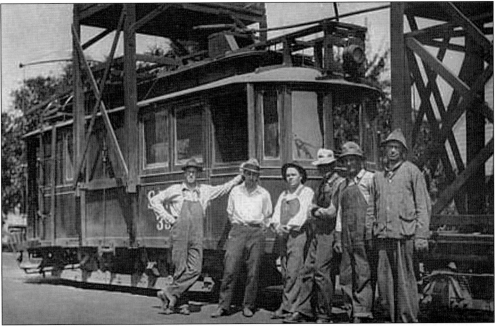

A 1909 railroad crew pauses to pose for a picture as they prepare to load a streetcar onto a railroad flatcar. It's unknown whether the car was being transported for repair or sale. (SPL: M.)

Salem residents complained of having to travel all the way out to Twelfth Street to pick up passengers and freight from the train, so in 1888 a horse-drawn streetcar line took people out to the Southern Pacific depot. In this photograph, taken in 1912, a brand new McKeon gasoline coach stands by the depot. (OSL.)

Reuben P. Boise Jr. and wife Milly (Breyman) Boise sit proudly behind the wheel of Salem's first electric automobile registered with the secretary of state's office. This particular model was the Columbus, made by Columbus Buggy Company. (SPL: M.)

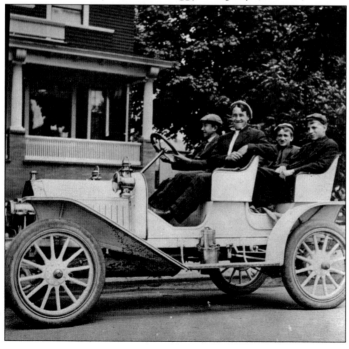

Donald Byrd (driver) and Harold Hager (right) sit in a 1909 Buick Model 10. The car was registered to Dr. W. H. Byrd. Dr. Byrd was a physician who practiced in Salem. (SPL: M.)

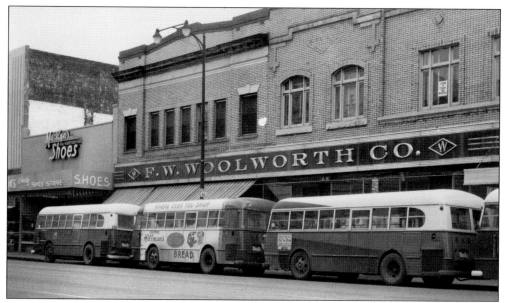

Buses started replacing streetcars on Salem streets in 1927. By 1959, they were a common sight. Here three buses line up in front of the F. W. Woolworth Building on South Liberty Street. Bus advertising was common back then as well. One of the buses has Hillman's Bread advertised on its side. (SPL: M.)

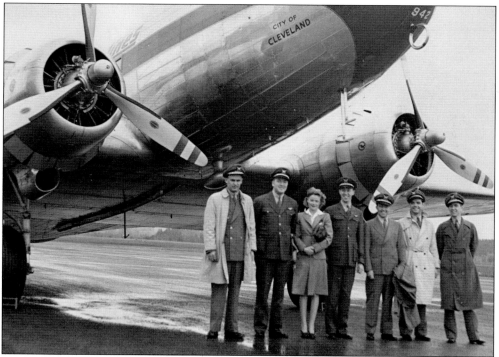

August 5, 1941, was a big day for Salem. The crew standing in front of this plane marked the first direct mail flight to Salem. The airplane was called the *City of Cleveland*. Airmail out of Salem started in December of that year, when United Airlines began regular commercial service. The captain of the *City of Cleveland*, S. H. Rehnstron, is second from the left. (SPL: M.)

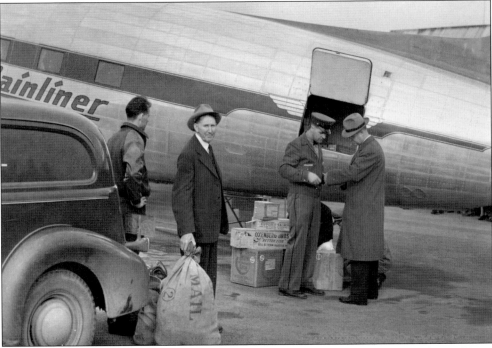

Fourteen thousand pieces of mail left on that first flight in 1941. From left to right are Harry Patton, postal messenger; Henry R. Crawford, postmaster; Armond Garrett; and A. O. Willoughby, superintendent of airmail. (SPL: M.)

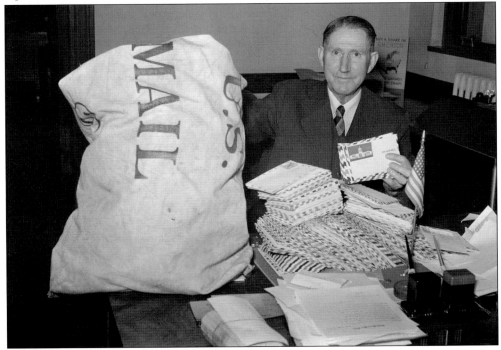

The Salem Chamber of Commerce issued first-day covers for the airmail shipment that left Salem in 1941. Postmaster Henry R. Crawford holds some of the letters in his hand. (SPL: M.)

Eight

FAITH AND EDUCATION

Faith and education were the goals of Salem's first residents. Jason Lee's mission was to bring the gospel to Kalapuya tribal members and their families. Lee also set up a school to help train Native American children. Though the mission converted few Native Americans, the religious roots of the missionaries encouraged the growth of many churches in the Salem area. William Willson, who came to Oregon to help Jason Lee with his Willamette Mission, donated property for several churches. Though Lee and Willson were Methodists, they helped congregations like St. Paul's Episcopal get started.

After the mission moved to Salem, the missionaries gathered on January 17, 1842, to create a school for their own children's education. They established the Oregon Institute. The board of trustees for the new school was comprised of Jason Lee, David Leslie, Gustavus Hines, Josiah Parrish, Lewis Judson, George Abernathy, Alanson Beers, Hamilton Campbell, and Dr. Ira Babcock. From these small beginnings, the first university in the West was born. Willamette University graduated its first student in 1859, the year Oregon became a state.

Salem's first public school was a log house or cabin erected in 1850 on the corner of Marion and Commercial Streets. Five years later, District 24 was formed. It wasn't until 1857 that the first tax levy raised $800 to finish the new Central School, built between Center and Marion Streets. During its first 15 years, teacher salaries were paid by a tuition fee of $4 per term. A teacher's year in 1871 consisted of four quarters of 11 weeks with vacations as "the board sees fit."

As Salem's public schools grew, so did an institution designed to educate Native American children. Chemawa Indian School, located on the north side of Salem, is the oldest continuously run Indian school in the United States, provided classes in sewing, carpentry, stock raising, and other vocations.

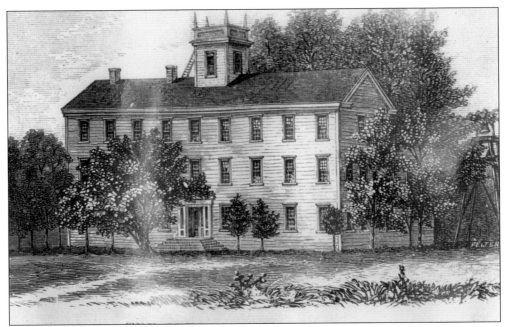

This is an 1842 illustration of the Oregon Institute, on the campus of what is now Willamette University. The university was born on January 17, 1842, when a group gathered in the home of Jason Lee to discuss creating a school for the children of the missionaries and other settlers. (SPL: M.)

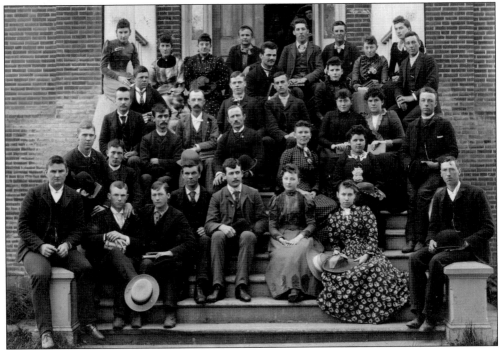

A group of students gather on what may be the steps of Waller Hall sometime between 1890 and 1900. It was at this time that the school colors, cardinal red and gold, were chosen. (OSL: Trover Collection.)